W9-DEB-192

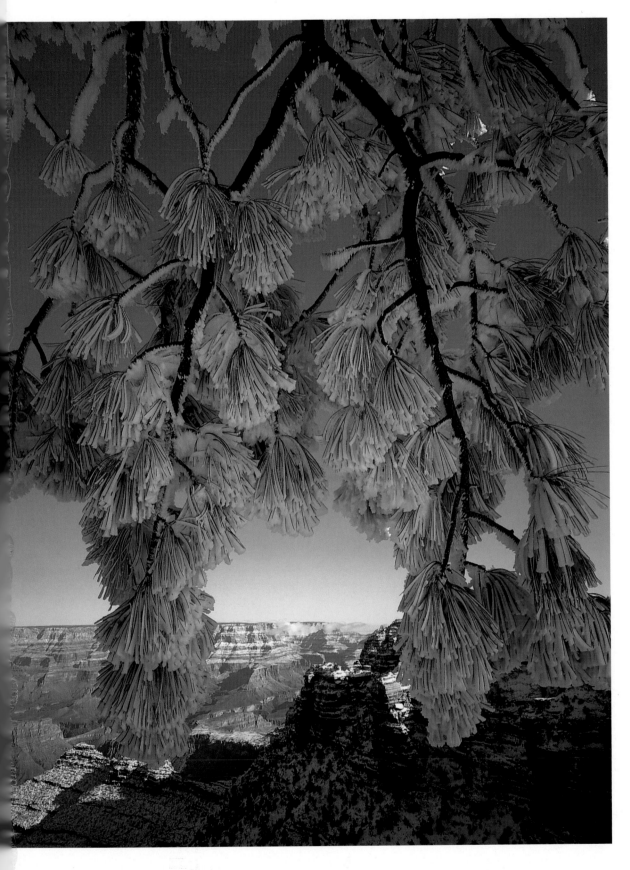

Large Format

Nature

Photography

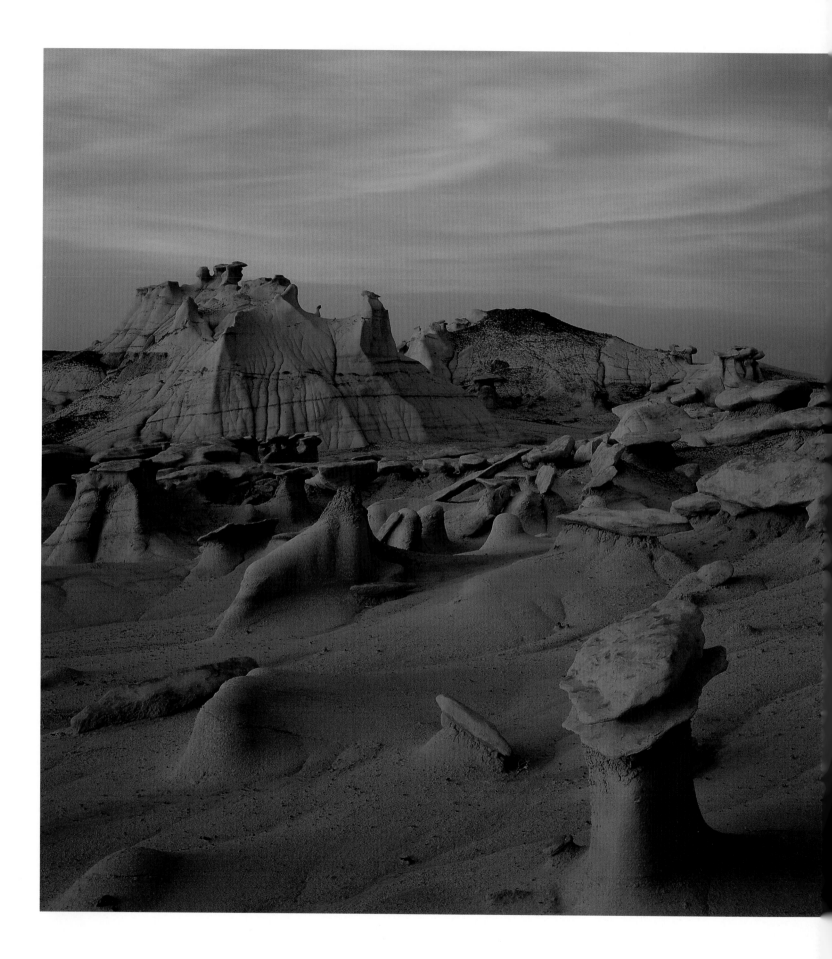

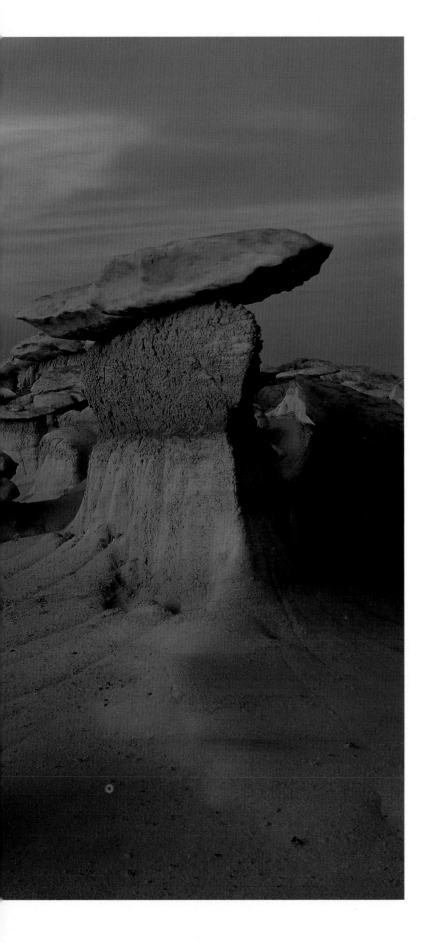

Large Format
Nature
Photography

Jack Dykinga

AMPHOTO BOOKS

AN IMPRINT OF WATSON-GUPTILL PUBLICATIONS

NEW YORK

Technical Note

It is not my intent that this book serve as a heavily technical reference on view cameras and all their features. Instead, it is my hope to reveal a bit about the ideas, thought processes, and considerations that go into making my images in the hopes that this will help experienced amateur or advanced large-format photographers in exploring and expanding their own vision. For those seeking thorough, expert information on the technical aspects of large-format view cameras, I recommend Leslie Stroebel's *View Camera Technique* (Focal Press, 1999). It is an essential reference for any serious large-format photographer.

Cover: Grand Prismatic Pool at sunset. Yellowstone National Park, Wyoming
Page 1: Snow-covered ponderosa pine *(Pinus ponderosa)* with North Rim in the background. Grand Canyon National Park, Arizona
Page 2: Eroded clay mounds with cap rocks at sunset. Bisti Badlands, BLM Wilderness, New Mexico

Senior Editor: Victoria Craven
Project Editor: Alisa Palazzo
Design: Eric Baker Design Associates
Production Manager: Ellen Greene

Typeset in Akzidenz Grotesk and Centaur

First published in 2001 by Amphoto Books
an imprint of Watson-Guptill Publications
a division of BPI Communications, Inc.
770 Broadway, New York, NY 10003
www.watsonguptill.com

Copyright © 2001 Jack Dykinga

Library of Congress Cataloging-in-Publication Data
Dykinga, Jack W.
 Large format nature photography / Jack Dykinga.
 p. cm.
 ISBN 0-8174-4157-3
 1. Nature photography. 2. Dykinga, Jack W. I. Title.

 TR721 .D95 2001
 778.9'3—dc21

 2001022768

All rights reserved. No part of this publication may be reproduced or used in any form or by any means—graphic, electronic, or mechanical, including photocopying, recording, or information storage-and-retrieval systems—without the written permission of the publisher.

Manufactured in Italy

1 2 3 4 5 6 7 8 / 08 07 06 05 04 03 02 01

SPECIAL THANKS TO:

Bill Atkinson
John Botkin at Photo Craft labs
Peter Ensenberger and Richard Maack at *Arizona Highways* magazine
Jeff Foott
Diane Graham-Henry, Philippe Vogt, and Martin Vogt at Arca-Swiss
Robert Kipling
Rod Klukus at Photomark, Phoenix, Arizona
Ron Leven, Dwight Lindsey, and Ulrich Eilsberger at Schneider Optics
Randy Prentice and Diana May
David Reilly and Nicole Mummenhoff at Lowepro
Robert Schaefer at Robert Schaefer Advertising
Rich and Susan Seiling, and Terrance Reimer
John Shaw
Sandy and Jay Smith
Russell Sparkman at Fusionsparks Media
Larry and Donna Ulrich

Contents

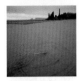
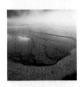

Introduction

Why large format? Sometimes, when I'm schlepping 50 pounds of camera gear on a hike that's way too far from the truck, I ask myself the same question. However, days later when I seat myself at my light table with a hot cup of coffee and a fresh box of transparencies from my lab, it's almost like Christmas! I open the box and lay out the chromes in neat piles according to subject matter. I look at each image through a loupe, noting a subtle wind movement here and a slight exposure problem there, but right there before me are several images that are breathtaking. The image area is so huge that you can see many compositions within the frame. The detail is amazing.

My background is in photojournalism. Using a pair of 35mm Leicas for wide-angle shots and a pair of Nikons for telephoto images, I always worked quickly. The speed and mobility afforded by 35mm cameras allowed me to capture whatever decisive moment presented itself to my lens. I shot everything on the move, recording action as it happened. Freezing the moment.

However, with my 4 x 5, my decisive moments require more planning, composing, and often a break in the wind. The camera itself is larger, more cumbersome, with multiple focus and perspective controls that slow a photographer's response to quick changes. Furthermore, it's mounted on a tripod in a fixed position. Any change in composition requires moving the tripod, changing lens orientation and focus, and checking and rechecking the change on the ground glass.

Going slowly isn't all that bad. It allows me to pay more attention to details. The inverted image-viewing on the ground glass defeats many budding large-format shooters. Yet for me, it's the best way to slow the process down and concentrate on a composition that's reduced to shapes and forms. Being dyslexic and left-handed doesn't hurt either. When I first peered into the ground glass, things finally looked right!

Still, it took me three years to feel semiconfident with my 4 x 5. I say semiconfident because I still make mistakes, still forget to tighten a control knob or stop down a lens. I have even made expensive mistakes such as not checking a lens mount and watching that lens smash into jagged lava formations. Each mistake has made me a better photographer. I've learned, sometimes painfully, from all of them. My wish for people reading this book is that they can minimize costly mistakes—yet know that mistakes are part of learning a complex technique—and become comfortable with large-format photography.

Hopefully, you'll feel as I do, finding the 4 x 5 camera to be the perfect tool for recording landscape images. We can celebrate together, recording on film the color and wonder of wild land, expressing our love of wilderness.

Coyote Creek running over sculpted sandstone with fremont cottonwood trees *(Populus fremontii)* in the background. Coyote Gulch, Glen Canyon, Utah

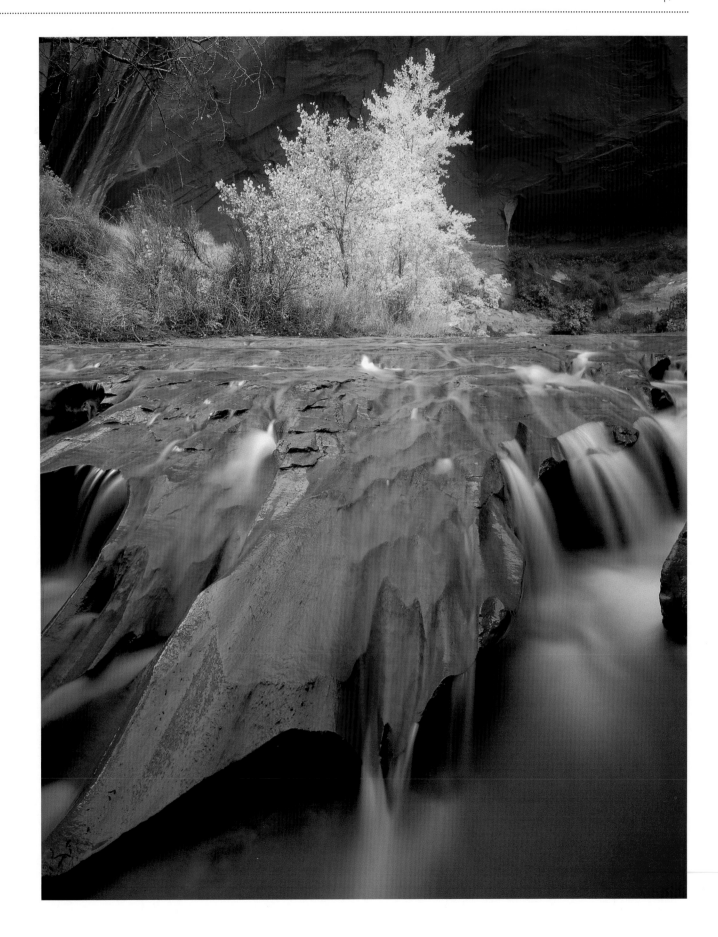

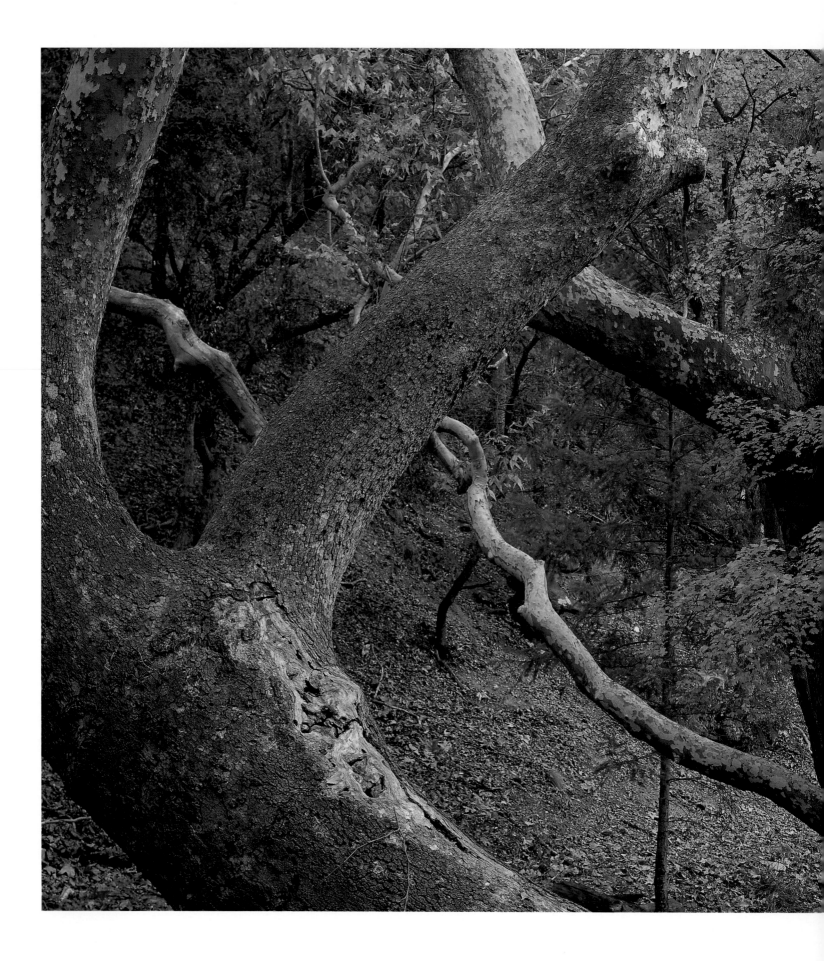

Composition

Bigtooth maples *(Acer grandidentatum)* amid Arizona sycamore trees *(Platanus wrightii)*. Ramsey Canyon, Mile High preserve of the Nature Conservancy, Arizona

I am constantly asked, "What camera do you use? Which lens do you prefer? What's your favorite film?" Photography is about seeing and light. Cameras and lenses are simply tools to place our unique vision on film. Concentrate on equipment and you'll take technically good photographs. Concentrate on seeing the light's magic colors and your images will stir the soul.

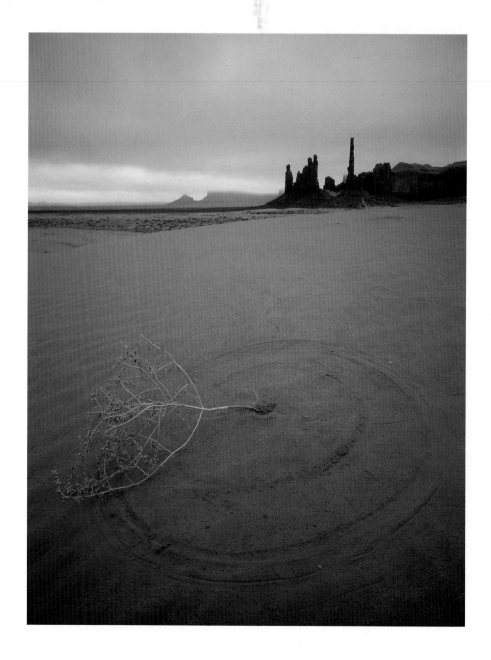

Totem pole and windblown plant.
Monument Valley, Arizona

**Arca-Swiss F-Field camera
with Schneider Super-Angulon
75mm lens**

*A perfect windblown circle in the sands of
Monument Valley imparts information and a
sense of place to the image. By choosing a wide-
angle 75mm Super-Angulon lens to emphasize
the foreground and the movement of the plant, I
was able to show the wind-shaped nature of
sand dunes.*

(SEE PAGE 63 FOR MORE ON LENSES.)

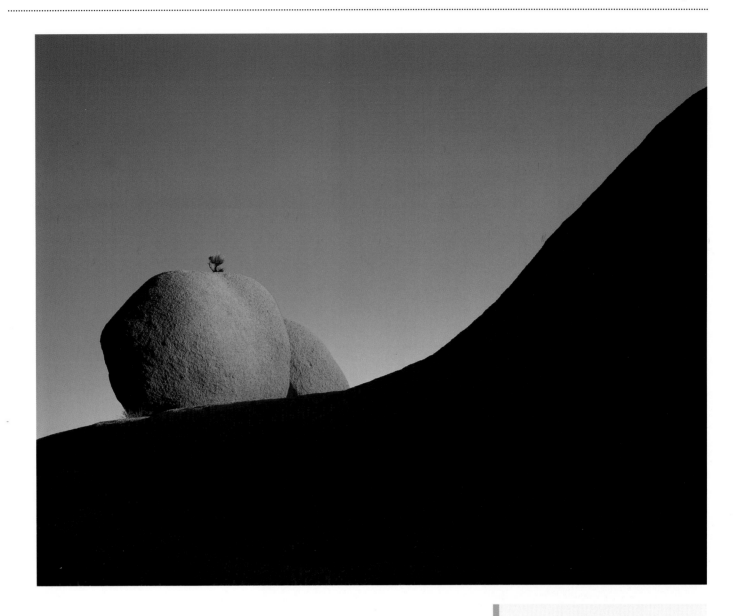

Information, Direction, and Simplicity Seeing is everything. How we see determines what we photograph. There are some basic "rules" governing composition, but they are merely suggestions of what has worked in the past. Take them and apply them to your own personal vision. The following are some of the things I try to watch for while composing a photograph.

I am drawn to elements within the composition that inform the viewer. By this I mean *inform* in a journalistic sense—the image imparts information. I am also always looking for bold lines in a composition, which will guide the viewer's eyes into the image. In addition, I don't try to pack everything into one image. I dissect the scene, looking for clean statements.

Granite boulders with turpentine bush (*Haplopapappus cuneatus*) at sunrise. Joshua Tree National Park, California

Arca-Swiss F-Field camera with Schneider APO-Symmar 180mm lens

The clean and simple sloping curve of the foreground boulder leads the eye into the image; this line, coming in from the edges of the frame, steers the eye into the center of the photograph. Make the corners of your composition "work" for you!

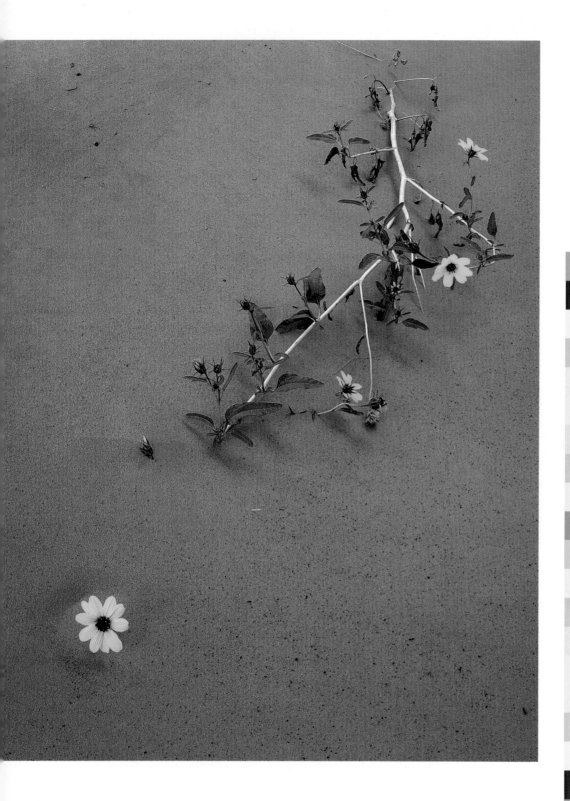

THIS PAGE: Half-buried sand sunflowers *(Helianthus anomalus),* Grand Staircase-Escalante National Monument, Utah

Arca-Swiss F-Field camera with Schneider Super-Symmar HM 120mm lens

The simplicity of this sunflower buried in the coral pink sands of Utah makes this photograph work and is a product of slicing one simple composition out of a grand landscape. The eye has no conflicts deciding where to look. In addition, the image provides information on the plant's ability to survive harsh environments.

OPPOSITE: Boojum trees *(Idria columnaris)* with lichen *(Ramalina reticulata)* in morning fog. El Rosario, Baja California, Mexico

Arca-Swiss F-Field camera with Schneider Super-Symmar HM 120mm lens

Images that display a minimum of color can also be effective in their simplicity. The thick fog surrounding the weirdly shaped trees not only creates a monochromatic environment, it also simplifies by obstructing the extraneous background; it is both clean and effective.

The Rule of Thirds

The eye seems to like a composition that places key elements of the image approximately 1/3 the distance from either top to bottom or left to right of the frame. To determine these locations, divide the picture area in thirds both vertically and horizontally, and then picture this imaginary grid in your mind as you compose. By laying this grid over the volcanic rock photograph opposite, you can see that the plant is placed 1/3 the distance from the left and 1/3 the distance from the bottom. It's "comfortable" for the eye to view.

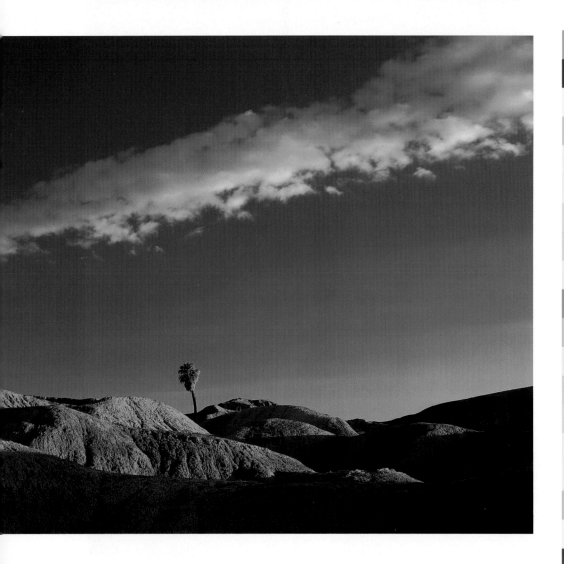

LEFT: California fan palm *(Washingtonia filifera)*. Anza Borrego Desert State Park, California

Arca-Swiss F-Field camera with Schneider APO-Symmar 210mm lens

By placing the lone palm tree in the V shape created by the intersecting hills, I emphasized its solitary existence in a harsh desert. The cloud formation and the rocky horizon line divide the composition into thirds horizontally, making use of the Rule of Thirds.

OPPOSITE: Lichen-covered volcanic rock with snakeweed *(Gutierrezia sp.)* in lava flow near Hunter Mountain. Death Valley National Monument, California

Arca-Swiss F-Field camera with Schneider APO-Symmar 180mm lens

The delicate dried plant amid the sharp crags of lava is interesting; but, when it is positioned at the left third of the shot and combined with the orange lichen juxtaposed against cool blue stones, the image becomes a successful composition.

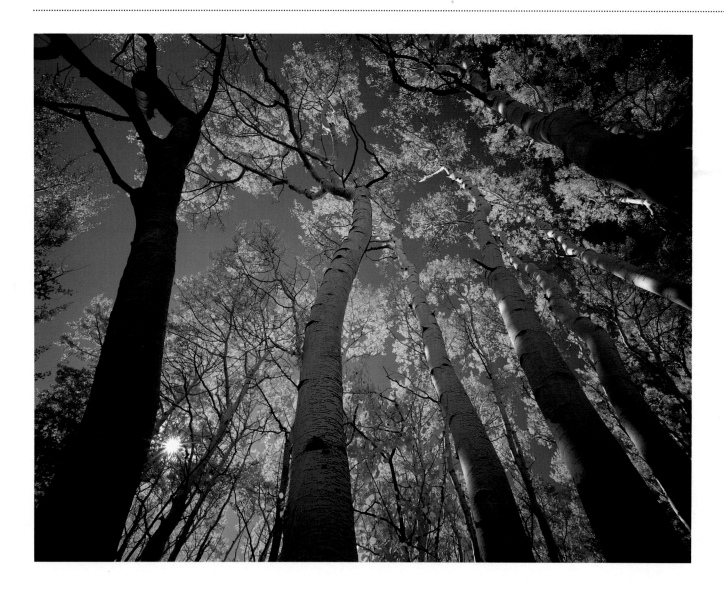

Quaking aspen (*Populus tremuloides*) on Boulder Mountain with fall foliage and morning sun. Dixie National Forest, Utah

Arca-Swiss F-Field camera with Schneider Super-Angulon 75mm lens

For the facing image, I opted for a centered composition. By contrast, in the above photograph I placed the main foreground tree and the sun to the left and composed an off-center image. They both work for me. Each has value.

Juxtaposition By contrasting harshness with softness or warm colors with cool colors, you gain impact. When you're in the field, notice how evening light colors the landscape with warm tones and how film sees shadows in cool, blue tones. The combination can be a very effective way to create compositions based on the juxtaposition of contrasting colors.

Symmetry Sometimes a composition is so strong and symmetrical, that it demands to be centered in the picture frame. Other times, an off-center composition seems more appropriate for the subject at hand.

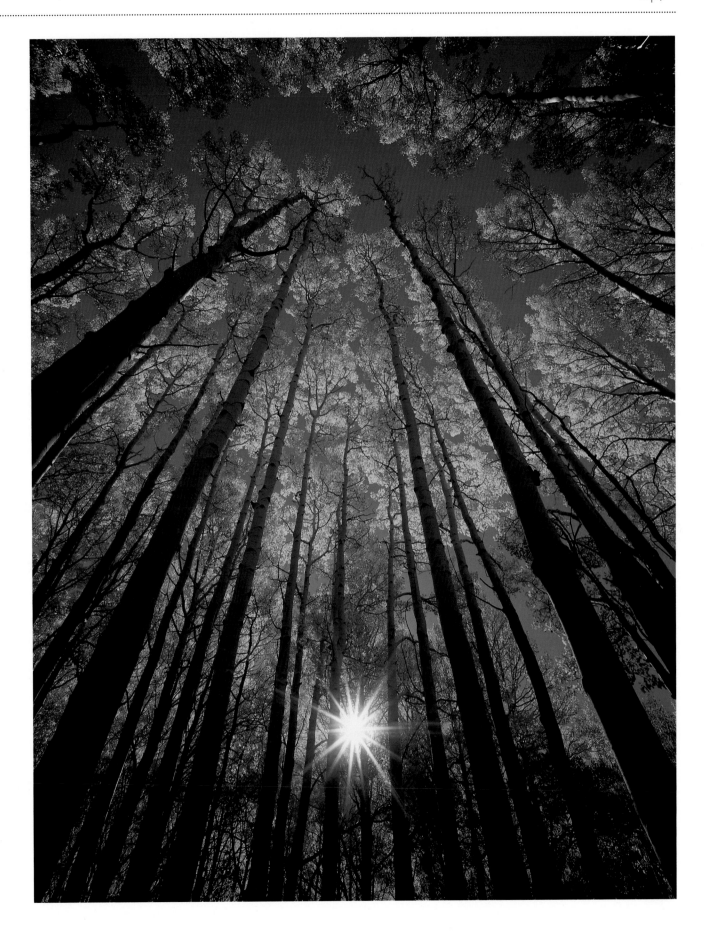

Working the Situation The real beauty of the large-format view camera is that you can study the large, inverted image in the ground glass over a long period of time. You can set up to photograph, compose carefully, but choose not to take the photograph. You can follow the rules or not follow the rules. You can finish composing, take the photograph, return to view the ground glass, and decide to tighten up the composition by moving closer or loosen it by moving back. I often finish photographing and, while checking the ground glass one more time, ask myself, What if? Then, I slowly try different things—slight changes in composition, and in the process, create an improved image.

This is the process I call working the situation. I look at all angles (often by simply walking around the subject). I view the scene from eye-level, looking down. I lie on the ground and look up. I imagine the subject close in the foreground or I back away and visualize it through a long lens, bringing in the background. Then, I set up. Often, I have to choose from several previsualizations. I sometimes return to favorite spots over and over again. Each time I try something different.

Saguaro cactus (*Carnegiea gigantea*) skeleton and mature saguaros at sunset in 1999. Cabeza Prieta National Wildlife Refuge, Arizona

Arca-Swiss F-Field camera with Schneider Super-Symmar XL 110mm lens

These saguaro cacti near my home in the Sonoran Desert have, over a period of years, become old friends. I have been there in 1991 when Mount Pinatubo's eruption in the Philippines brought crimson sunsets to the desert southwest. I have watched as each year their numbers have decreased. I have seen them under the spectacular sunsets of 1993. Their skeletal remains greeted me during my 1999 trip. I lament their passing, but rejoice in finding young saguaros hidden in the underbrush. You see, I've gotten quite close to my subjects.

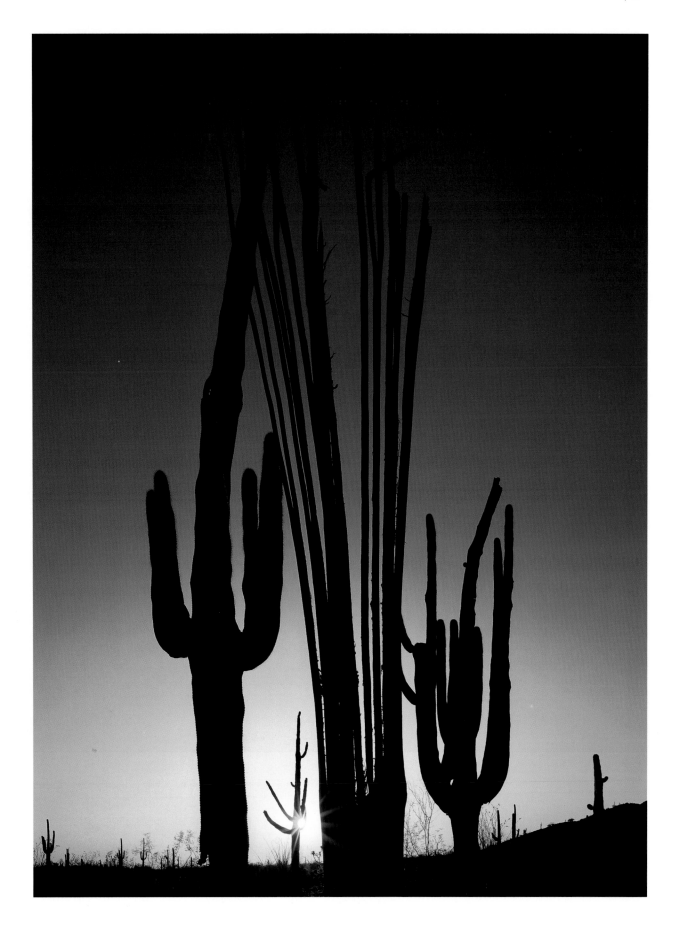

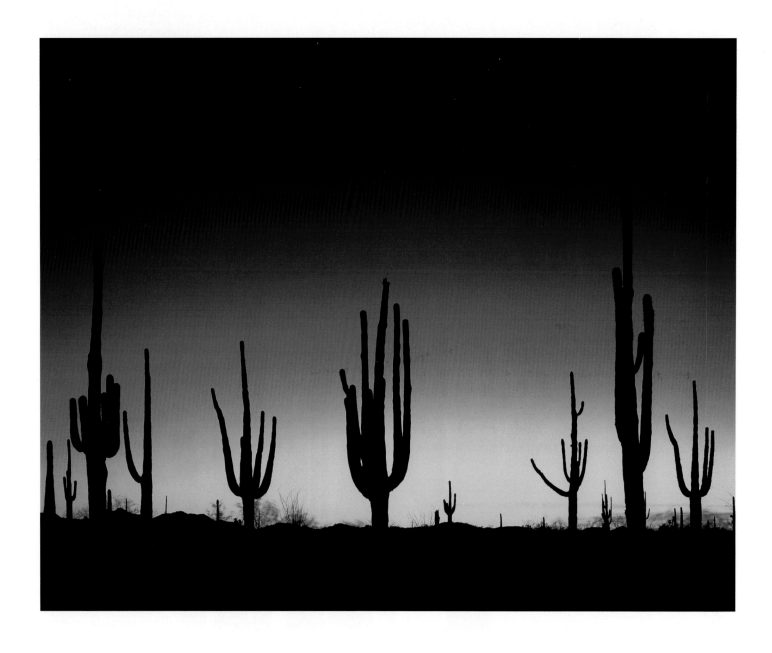

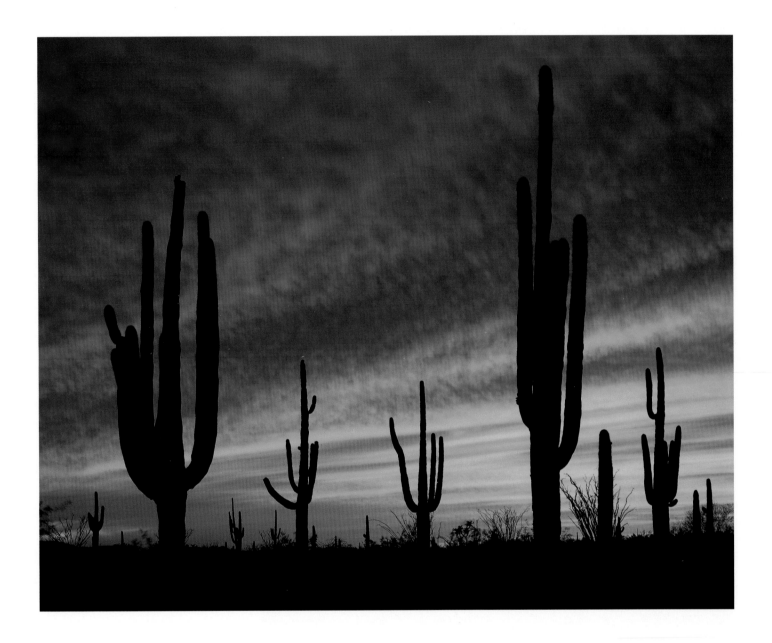

Format: Why 4 x 5?

There's something about the ratio of 4 to 5 that my eye just seems to embrace. It's the way I see. Compositions seem to fit perfectly into this "window." I can frame my scene either vertically or horizontally by changing the orientation of the film back. Of course, it doesn't hurt that this same format fits the layout requirements of most publications to which I submit images. The 4 x 5-format camera maximizes image potential while still being portable enough to carry into the wilderness. It's a good compromise between the bulk and size of the cumbersome 8 x 10 camera and the 35mm camera's mobility but small image size. It's perfectly suited for recording nature's splendid landscapes.

When I first picked up a 4 x 5 camera, I used it pretty much like an overgrown Leica. I pointed it and shot. I had no idea of the potential of such a camera. I just wanted a huge image.

Big is good . . . don't get me wrong. But today, I've grown to truly appreciate the 4 x 5 for its other assets, as well. It can control the focus plane, bringing the extreme foreground and background in simultaneous sharp focus, and make perspective adjustments while rendering incredible detail by changing the alignment relationship between the film plane and the lens.

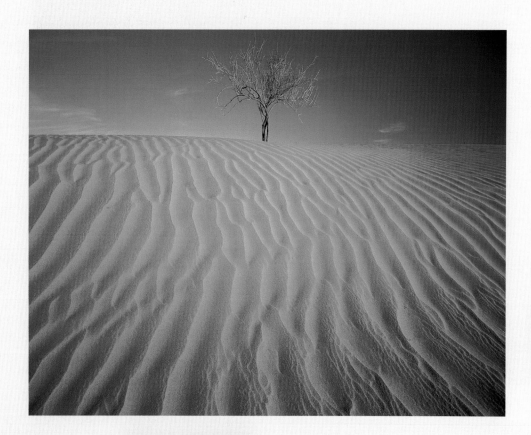

Wild buckwheat *(Eriogonum sp.)* in the northern Sonoran sand dunes. Gran Desierto Altar, Sonora, Mexico

Compare the same subject captured with my Nikon 90s and 20mm lens below versus the 4 x 5 transparency above taken with my Arca-Swiss F-Field camera and a Schneider Super-Angulon 75mm lens. The overall image area is so much larger in the 4 x 5 version that virtually grainless enlargements are possible.

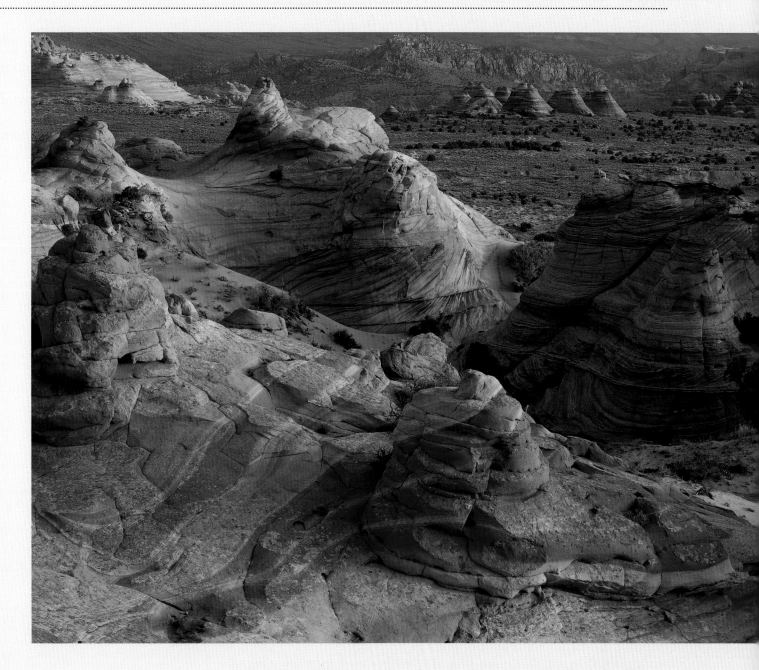

Eroded, petrified sandstone dune formations at sunrise. Paria Canyon-Vermilion Cliffs Wilderness, Arizona

Arca-Swiss F-Field camera with 305mm Schneider G-Claron lens

The large image size of the 4 x 5 format renders amazing detail. You find images within the image.

All this comes with a price, however. You must give up a good deal of mobility and spontaneity. With most cameras, you see the subject and take the picture. However, with a view camera, you must compose the photograph, viewing through the lens opened to its largest opening with the shutter open. Then you close the shutter, set the proper *f*-stop and shutter speed, insert the film, and finally take the photograph—all without actually seeing the image through the viewfinder as you take it.

This sacrifice means that you need to plan ahead—to anticipate the light before it happens—instead of merely recording what you see. When you plan ahead, after you determine and focus your composition you have the luxury of watching the light level and color ebb and flow. You're free to wait for that prime moment.

Preplanning

A good friend of mine, photographer Jeff Foott, offers that the reason most photographic situations don't work out is that the photographer was "late for work." Simply put, this means there was no preplanning, no anticipating the light or scouting the location involved.

With large format photography, preplanning is essential. Friends of mine kid me because I wear a compass attached to my watchband. I use it to scout sites and plot the sun's location at sunrise or sunset. It may look silly at cocktail parties, but it works for me!

I begin by walking around camera-free, using my fingers and thumb to frame potential compositions. I search out images as I hike through the landscape. This practice is a carryover from my days as a photojournalist. I wouldn't dream of trying to photograph people without getting to know them first. The same applies for photographing the landscape. You need to get to know the place. Do research before your trip begins. Study maps and read all you can about the location. I have friends who bring their Nikons along, with a medium zoom lens, to help them visualize potential images.

Scouting the location and the sun's position, and even picking which lens you'll use, ensures success when the light turns a scene into magic. You just don't have the option of driving up at the last moment, pulling out your 35mm, and firing away with your motordrive.

It's not easy to make the transition to large-format photography. Film and processing are much more expensive, so mistakes and lessons will come with a heavy price tag. From the time I began working with my first old Crown Graphic, it took me three years to become proficient. I was taking pictures immediately, but most were flawed. Any success I have had came from listening to accomplished photographers such as Jerry Jacka and Phil Hyde tirelessly explain each mistake I made, speaking *very slowly* so that I'd understand. I studied their work and tried to guess the lens and exposure time they used.

When I bought my first serious field camera, it was a Wista DX2. I chose it for its lightweight cherry-wood construction and relative stability. Once I unwrapped the camera, I spent hour after hour—using a normal (210mm lens)—trying every possible movement before ever getting a box of film. I set up and focused, did everything but shoot film. Practicing like this is worth it.

Teddy bear cholla *(Opuntia bigelovii)* and land formations at sunset. Kofa National Wildlife Refuge, Arizona

Wista DX2 camera with Schneider Super-Angulon 75mm lens

By anticipating the sun's position by using a compass, you can capture dramatic shadows without your own shadow dominating the composition.

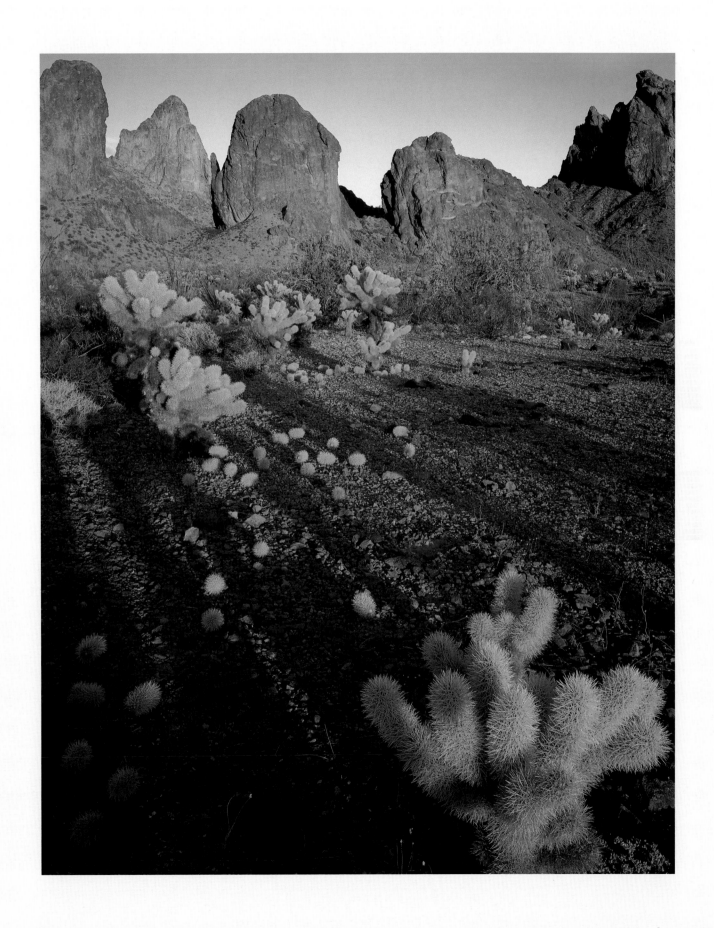

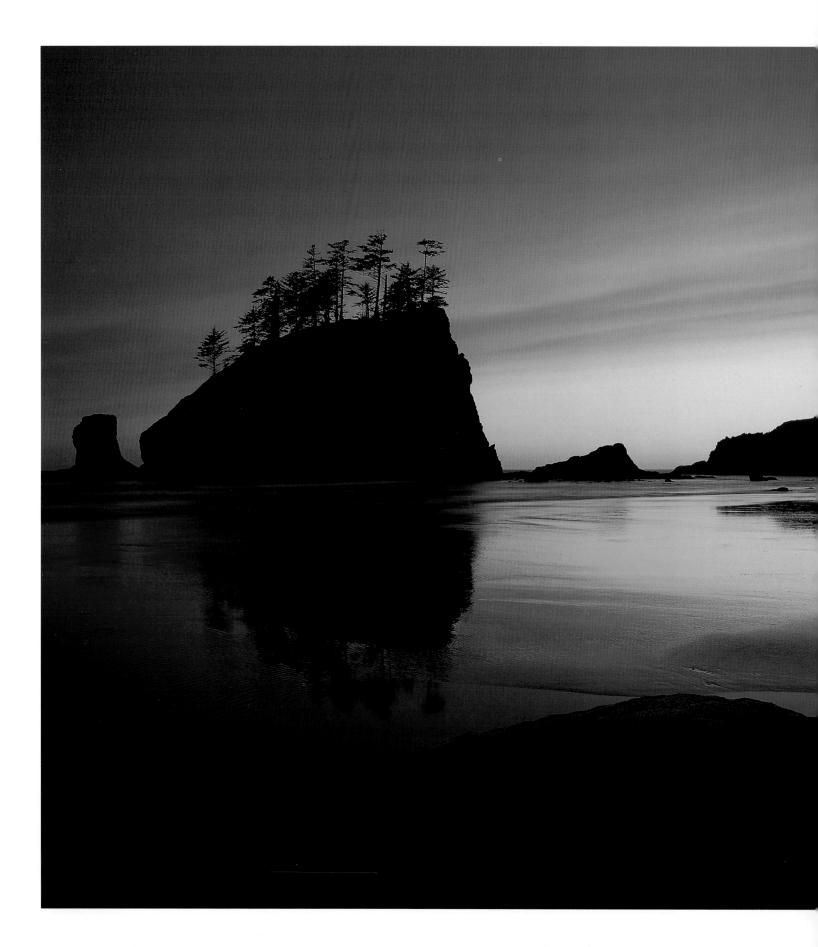

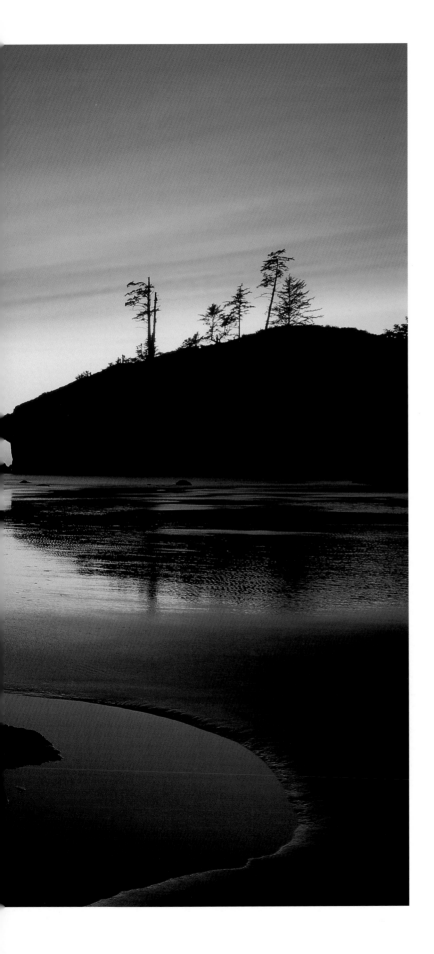

Light

Seastacks and receding tide at sunset.
Olympic National Park, Washington

E ven the drabbest, most ordinary scene is transformed when bathed in what I call *the sweet light*. I can think of countless situations when my composition was set and ready, but then the light changed everything. Sweet light is, above all else, temporary light. Its changing nature is what makes it interesting.

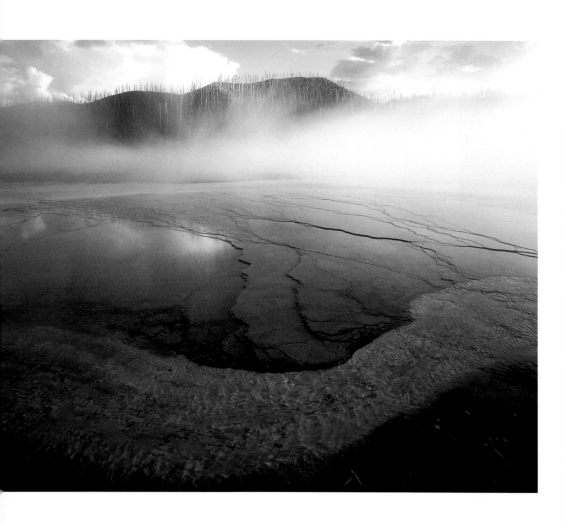

Grand Prismatic Pool at sunset with terraces of bacteria mats and red algae ribbons in the foreground (first composition). Yellowstone National Park, Wyoming

Arca-Swiss F-Field camera with Schneider Super-Angulon 75mm lens

Here at Yellowstone National Park, I was attracted to a ribbon of algae amid the terraced bacterial mats surrounding Grand Prismatic geyser. I worked hard at creating a very nice composition, using my 75mm Super-Angulon lens to capture the red algae curving through the foreground and the steam rising in the background (left), and managed to expose several sheets of film of this composition.

As the sun dipped lower, I noticed that the ribbon of algae's apparent destination was toward the horizon line and infinity (opposite). I grabbed my tripod, repositioned and quickly reset the camera, and managed to expose several more sheets of film, again using my 75mm lens.

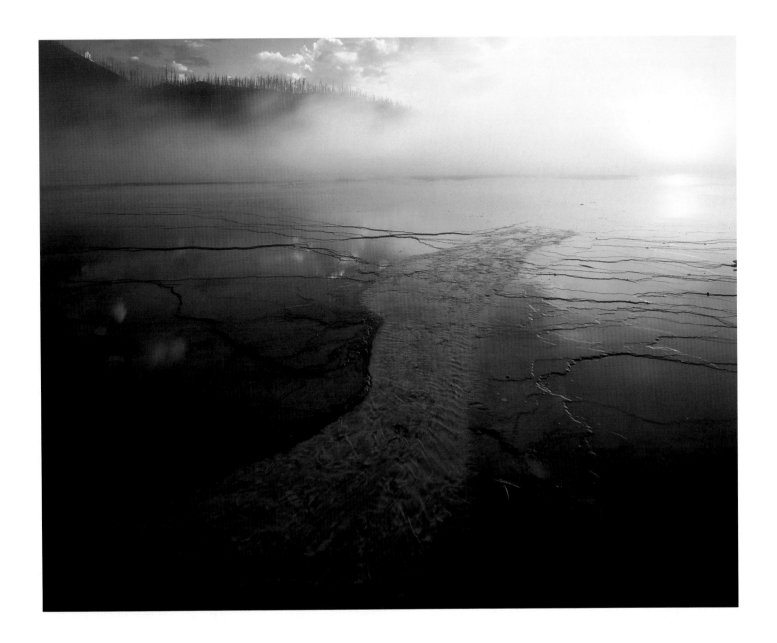

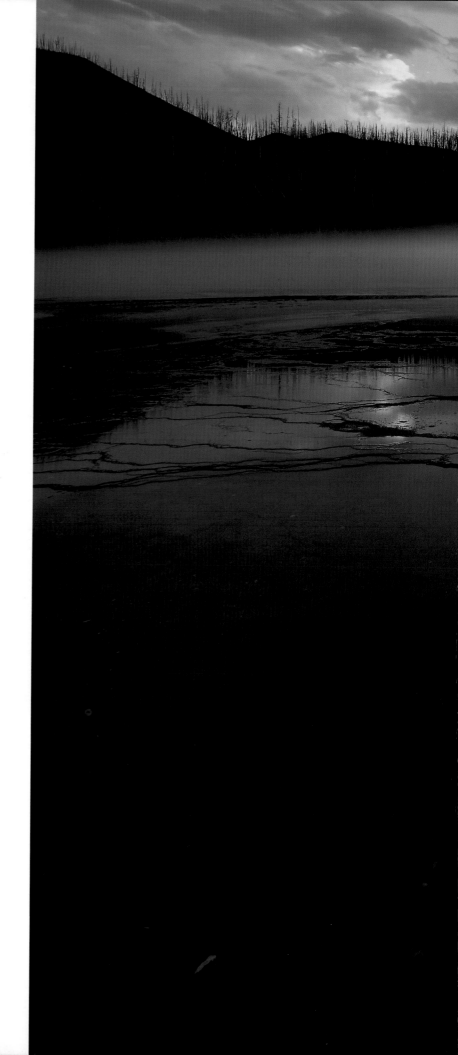

Grand Prismatic Pool at sunset (final
composition). Yellowstone National
Park, Wyoming

**Arca-Swiss F-Field camera
with Schneider Super-Angulon XL
58mm lens**

*The light was beginning to fade when I realized
that my composition was still too tight; I wanted
to capture the sinuous, riverlike look of the algae.
Off came the 75mm lens and on went the
58mm Super-Angulon XL lens. Recomposing
and refocusing quickly, I managed to expose half
a dozen sheets before the sun finally dropped out
of sight. The setting sun became an extension of
the ribbon algae, which was accentuated by the
use of the 58mm lens. I had what I was after!*

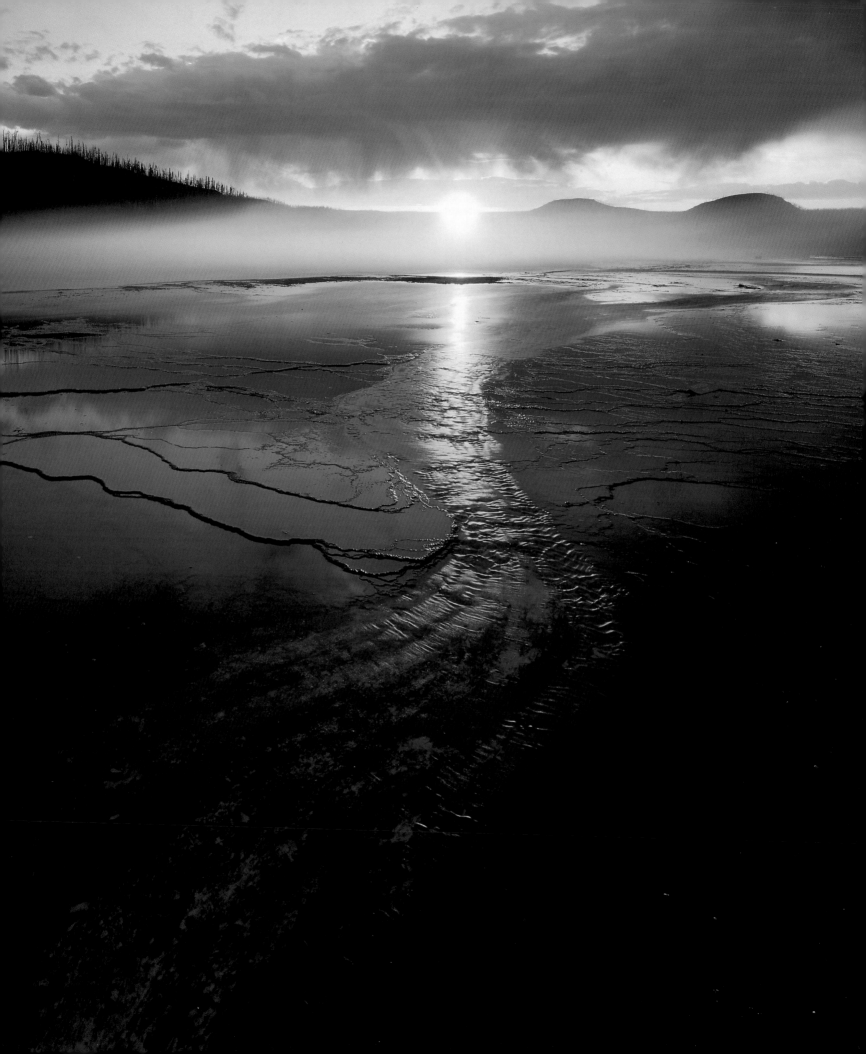

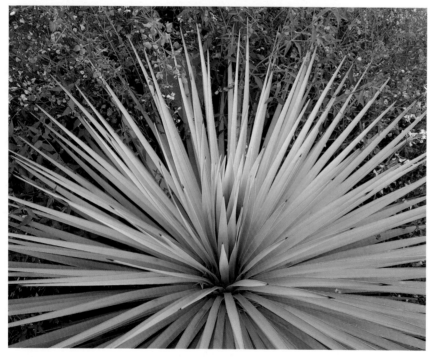

THIS PAGE: Rosette of yucca blades against flowering dicliptera. Tucson, Arizona

Arca-Swiss F-Field camera with Schneider APO-Symmar 180mm lens (top); Arca-Swiss F-Field camera with Schneider APO-Symmar 180mm lens and Tiffen 812 warming filter (below)

Harsh, direct late-morning sunlight—with its steep range of contrast—makes the yucca in the top image too bright, or "blown out," against the surrounding flowering dicliptera. In soft light (below), as the plants fall into afternoon shade, the contrast range lessens and the color of the yucca blades seems to glow. I added a Tiffen 812 warming filter to compensate for the longer exposure in "cooler," open shade light.

OPPOSITE: Flowering borrego locoweed (*Astragalus lentiginosus borreganus*) at sunrise with Providence Mountains in the background. Mojave National Preserve Kelso Dunes, California

Arca-Swiss F-Field camera with Schneider Super-Angulon 75mm lens

Here in the Kelso Dunes, the soft light on the foreground plants supplies the detail information of the scene, while the background color of sunset light sets the mood. The brighter light on the distant dunes draws the eye into the composition.

When early morning or late afternoon sunlight is horizontal it emphasizes the texture of the landscape while bathing the subject in a warm glow. It's as good as it gets! Sometimes, however, soft light that occurs in shaded areas brings a scene to life. It allows details to be rendered more effectively on film by keeping the difference between highlights and shadows to a minimum.

By contrasting open, shadow areas (large expanses of space that are in shadow rather than direct sunlight) with selectively sunlit areas, you can use light to draw the eye further into an image.

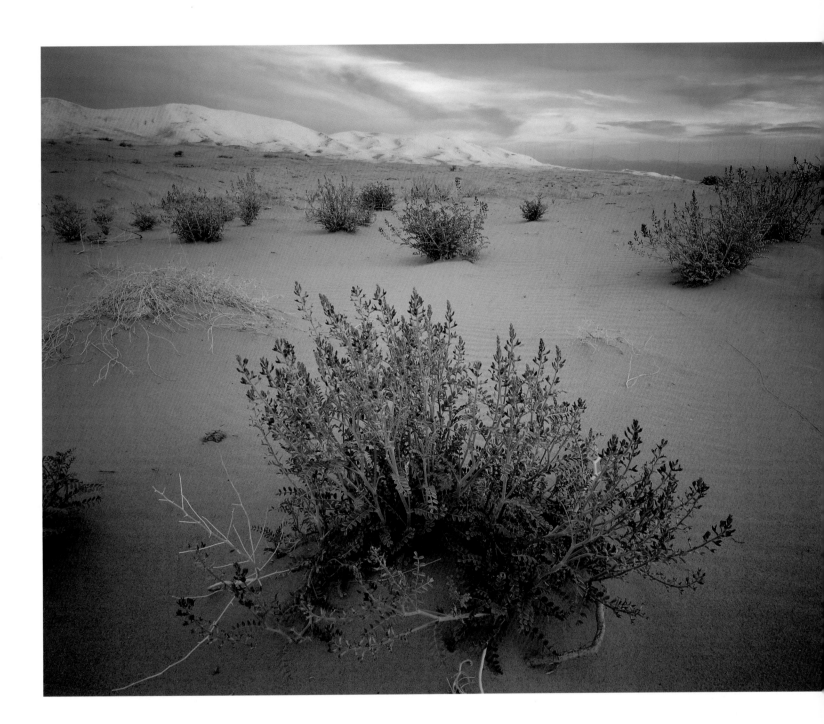

The saguaro cacti images on pages 19–21 offer another example of the rewards of light. In November of 1991, the desert skies near Tucson were aglow at sunset from the eruptions of Mount Pinatubo in the Philippines. The cliché image of silhouetted saguaro cacti transformed into something otherworldly in the yellow and red bands of the sunset afterglow. I really was set to take an image of the sun at the horizon when I began to notice the gradual increase in color. The longer I waited, the more color appeared. I exposed at least a dozen sheets of film recording the sweet light of a volcano-polluted sky.

Sweet light is truly a gift. But remember, you must be ready to receive that gift. Patience is truly a virtue.

Mount Hayden at sunset. Point Imperial, North Rim, Grand Canyon National Park, Arizona

Arca-Swiss F-Field camera with Schneider APO-Symmar 180mm lens

Don't give up on the light. My trek to the farthest point of Point Imperial on the North Rim of the Grand Canyon was a hopeless situation. The entire canyon was a "white out"—fog obscured everything. Grumbling under my breath, I trudged off thinking, What the heck . . . I'll at least try. After I set the camera up and waited perhaps half an hour past sunset, the clouds suddenly parted. Not only that, they soon glowed with pastel hues. More sweet light!

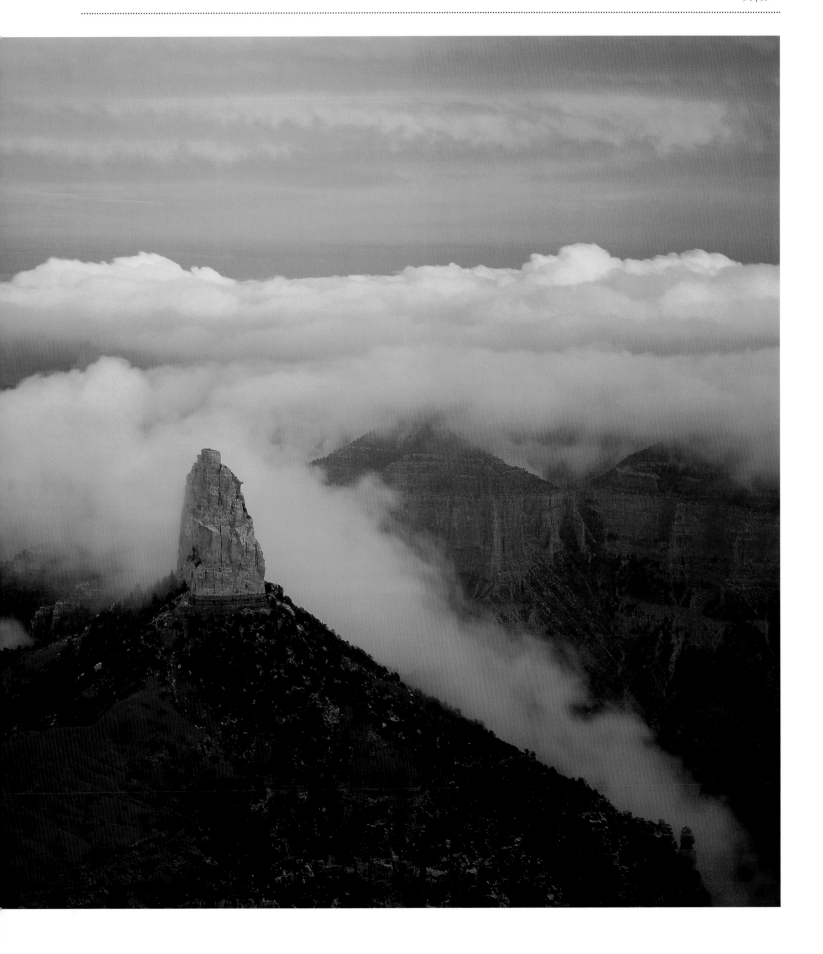

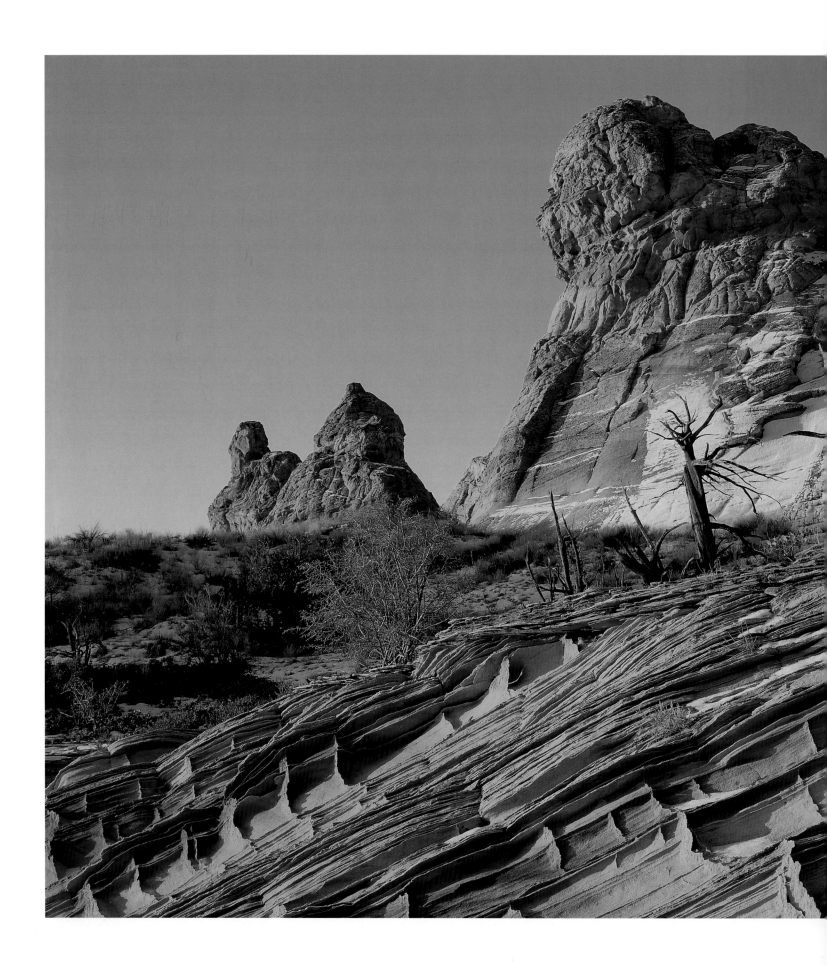

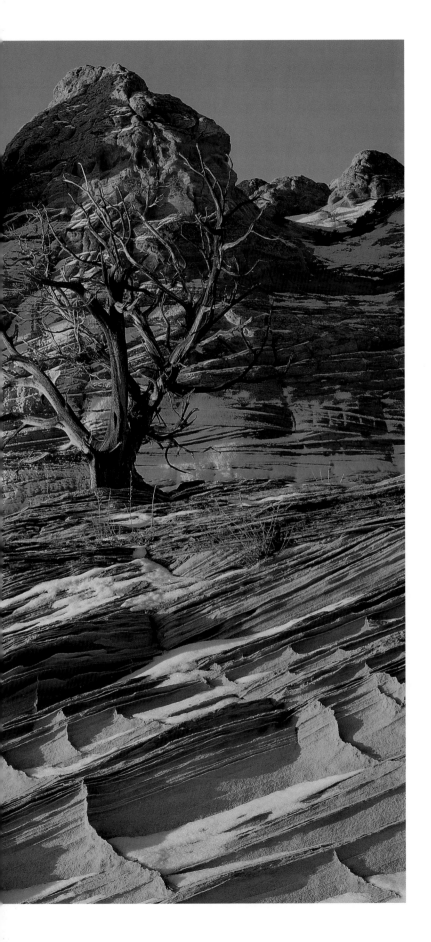

Focusing the Camera

Snow on petrified sand dunes at dawn.
Paria Canyon-Vermilion Cliffs
Wilderness, Arizona

The view camera is this giant box that has all these controls that can change the orientation and distances between the lens and the film. You can focus forward and back, with either the front or rear control. You can raise or lower the lens relative to the film, or shift the lens from side to side. You can even tilt the lens forward and backward (called a *tilt* movement) or side to side (called a *swing* movement) to keep various elements of a subject in sharp focus.

While daunting to learn and comprehend at first, this camera's ancient design can produce images that replicate that certain feeling of awe you felt when you initially viewed a spectacular scene.

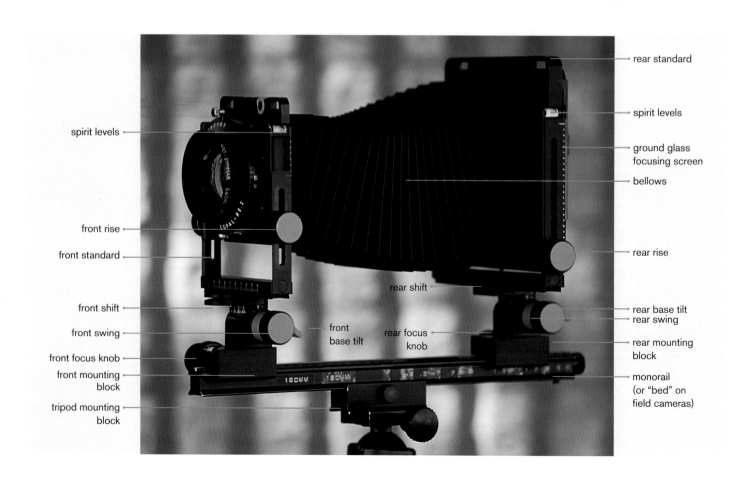

spirit levels

front rise

front standard

front shift

front swing

front focus knob

front mounting block

tripod mounting block

rear shift

front base tilt

rear focus knob

rear standard

spirit levels

ground glass focusing screen

bellows

rear rise

rear base tilt
rear swing

rear mounting block

monorail (or "bed" on field cameras)

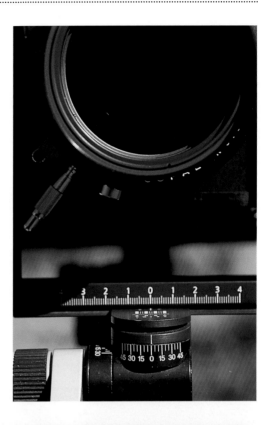

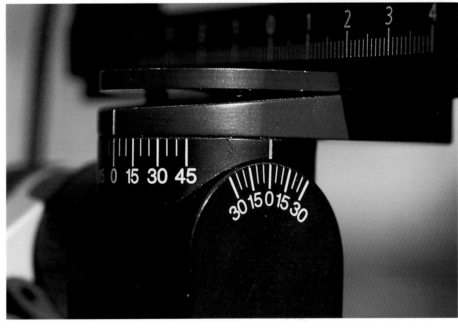

OPPOSITE: *Camera control elements. Note that the controls on some of my cameras have been moved to the other side of the focusing block to accommodate being left-handed.*

THIS PAGE: *Details of the zero positions on my Arca-Swiss F-Field camera.*

Setup Whenever I take my camera out of the bag and lock it down on the tripod, I *always* check to see that all the controls are set in neutral, or zero, positions. Many 4 x 5 cameras have zero "indents" or "click stops" that allow the photographer to feel when the rise, tilt, or swing is in a neutral, or zero, position. This is a must for any serious large-format photographer. I have wasted countless sheets of film rushing to set up and noticing too late that my Arca had been jarred out of its neutral position during my hike to the location. The result: Every image was slightly out of focus! At the end of each shoot, I carefully return all settings to the zero positions, as well. Always, always, always check these settings.

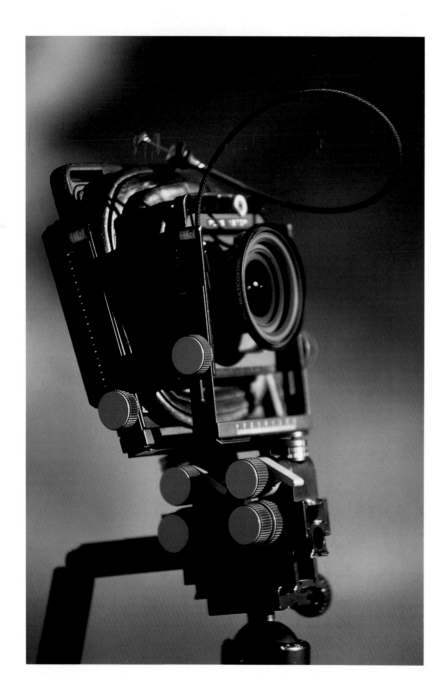

Arca-Swiss F-Field camera with bag bellows and shortened collapsible rail.

Selection I use different cameras for different situations. I chose the Arca-Swiss F-Field 4 x 5 monorail camera for its ability to be configured in a wide variety of ways, enabling it to become either an extreme wide-angle camera or an extreme telephoto camera. Being able to change the backs, bellows, and lenses (see diagram on page 38), allows the Arca to function as a wide-angle camera, a telephoto camera, or a macro camera, using either roll or sheet films. The Arca's combination of relatively light weight (6 pounds) and modular features that allow multiple formats, interchangeable bellows, rails, and both base tilt and axis tilt gives me the versatility I require. This is a monorail camera with smooth, very precise controls, but with the portability and weight of a field camera. However, when I'm backpacking great distances, I choose my very lightweight Wista DXII wooden field camera. At just over 3 pounds, it's my lightest camera.

With a view camera, you are free to set the space between the film and lens to any distance you choose, from short focal length wide-angle lenses to long focal length lenses. In order to speed the setup process when using my Arca, I lock the front standard (holding the lens) in a fixed position at the front end of the monorail. With whatever focal length lens I choose to mount, I merely move the back standard (holding the ground glass and film) away from the front standard the appropriate distance to accommodate the lens' focal length or to render the subject in sharp focus. I use the rear controls in most instances. By locking all the front movements down tight, I effectively cut my chances of making mistakes in half. I'm free to concentrate on the rear movement controls. Furthermore, I eliminate any chance of inadvertently photographing the monorail when using a very wide-angle lens, since the lens is at the very end of the rail.

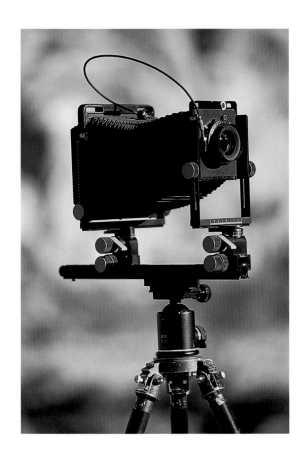

ABOVE: *Normal bellows and standard rail.*

RIGHT: *Telephoto bellows with long rail.*

When I set up my Wista camera everything is reversed. The back is stationary, and instead of focusing by moving the camera's back standard, I move the front standard and lens forward and back. To accommodate lenses of different focal lengths, I lock the front standard into positions on the bed at greater or lesser distances from the film plane so that each lens can be in sharp focus at infinity. This allows the bed to rack forward as you focus, extending out to accommodate close-up situations. There are grooved markings etched into the brass camera bed to act as reference points for setting the correct focal lengths corresponding to each lens. You can lock the Wista's front standard to any of these stop points, each spaced 5mm apart. With my shortest lens (75mm), the front standard is locked down at one of the nearest points (closest to the film plane). Conversely, with lenses of 180mm and longer, the standard is locked clear to the end of the focusing rail.

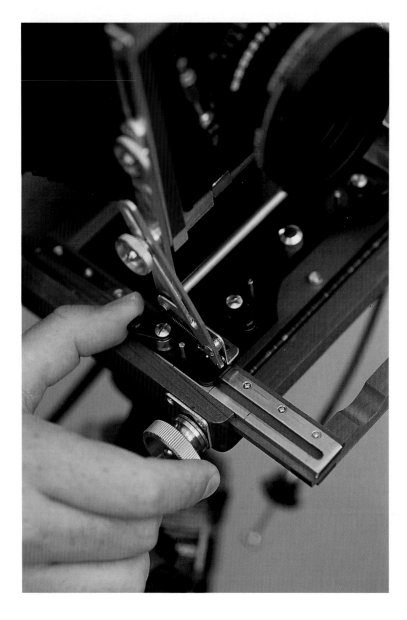

My Wista DX2 camera with markings on the camera bed for positioning the front standard.

Here, my son Peter makes a rear tilt adjustment (rotating the camera back on a horizontal axis) to achieve focus both near and far.

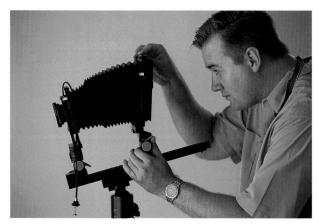

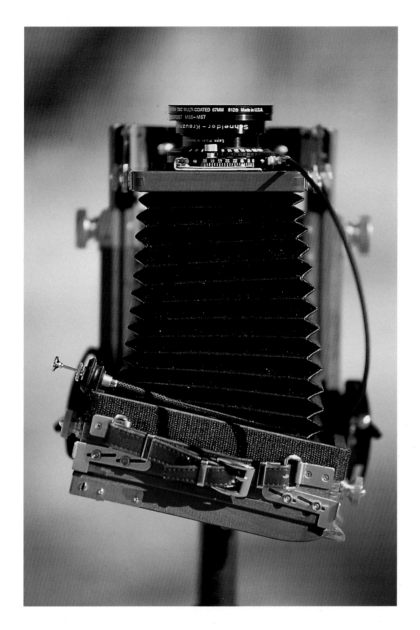

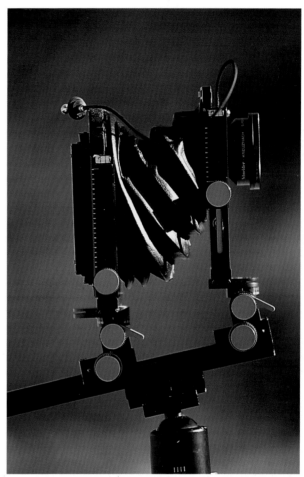

ABOVE: *A* rear swing *(rotating the camera back on a vertical axis) changes the plane of focus in a composition that has a close subject on the left and a distant object on the right, both in sharp focus.*

RIGHT: *The* front rise *is another movement commonly used in the field.*

Camera Movements My view camera's movements can be adjusted to accommodate the irregularity of the landscape, bringing most or all elements within a photograph in sharp or nearly sharp focus.

Tilt

The movement used most often, by far, is the *back tilt.* Simply put, this camera adjustment allows you to change the relative distances between the film and the lens in such a way that causes both near and far objects to be in sharp focus simultaneously.

Tilting the camera back using a *base tilt* brings both the foreground and background into focus on the same plane and exaggerates the foreground's size. Tilting the rear standard increases the bellows draw, so to compensate, the overall focus must be shortened. The process is then repeated starting at the background and finishing with the foreground until they both come together in sharp focus.

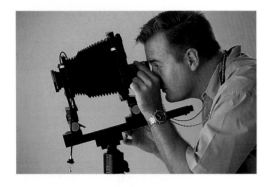

Begin by focusing at the farthest point, always on the bottom of the projected image on the ground glass and closest to the base tilt axis.

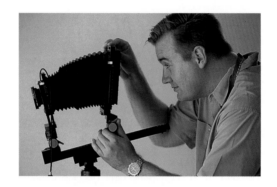

Tilt the rear standard, bringing the closest point (on the top of the projected ground-glass image) of the composition into sharp focus by tilting the standard toward your eye.

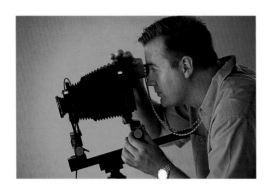

With the loupe in place, fine-tune the foreground focus and lock the standard into place.

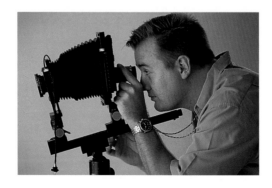

Finally, adjust the focus knob to compensate for the change in focus created by tilting the back.

Seeing the camera front and back without the bellows helps in understanding the various camera adjustments.

Camera adjustment illustrated here: back base tilt

Equipment shown: Arca-Swiss F-Field camera with Schneider 58mm Super-Angulon XL lens

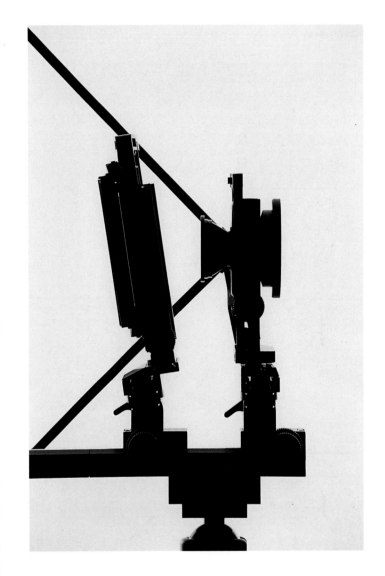

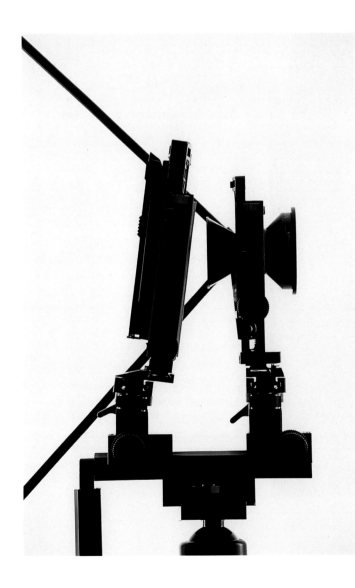

Camera adjustment: back forward base tilt

Equipment shown: Arca-Swiss F-Field camera with Schneider 75mm Super-Angulon lens

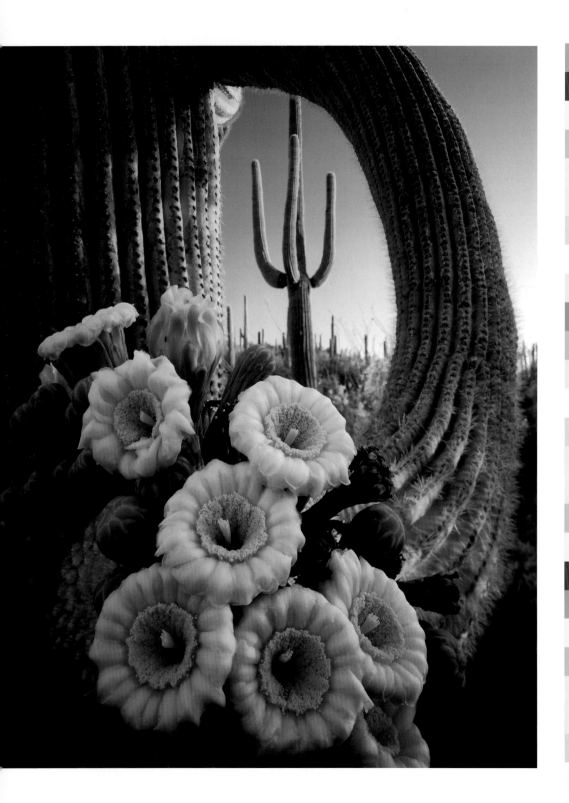

LEFT: Saguaro cactus *(Carnegiea gigantea)* with its flowers at dawn. Saguaro National Monument Tucson Mountain Unit, Arizona

Arca-Swiss F-Field camera with Schneider Super-Angulon 75mm lens

The cactus flowers in the foreground are exaggerated in size and, along with the more distant cacti, are in sharp focus with the use of a back tilt.

OPPOSITE: Sandstone rock formations known as the Organ framed by icicles at sunrise. Arches National Park, Utah

Wista DX2 camera with Schneider Super-Angulon XL 75mm lens

Sometimes, the foreground is not on the ground in front of the camera but hanging above it. Here, icicles hanging from a tiny frozen waterfall form the foreground, framing rock spires in the distance. To begin, I focused at the bottom of the ground glass (closest to the hinge point), but this time I pushed the top of the rear standard forward to bring the rock formations, near infinity, into sharp focus. I then refocused and used my loupe to check the icicles, increasing the bellows draw until they were sharp. I slowly tilted the back again, bringing the distant rocks into sharp focus, too, checking and rechecking the focus until both the top of the icicles and the distant rocks were both sharply in focus. In order to bring the bottom of the icicles into sharp focus, I had to stop down the lens (in this case a 75mm Schneider Super-Angulon) to its smallest aperture to give the appearance of sharp focus at the icicle tips.

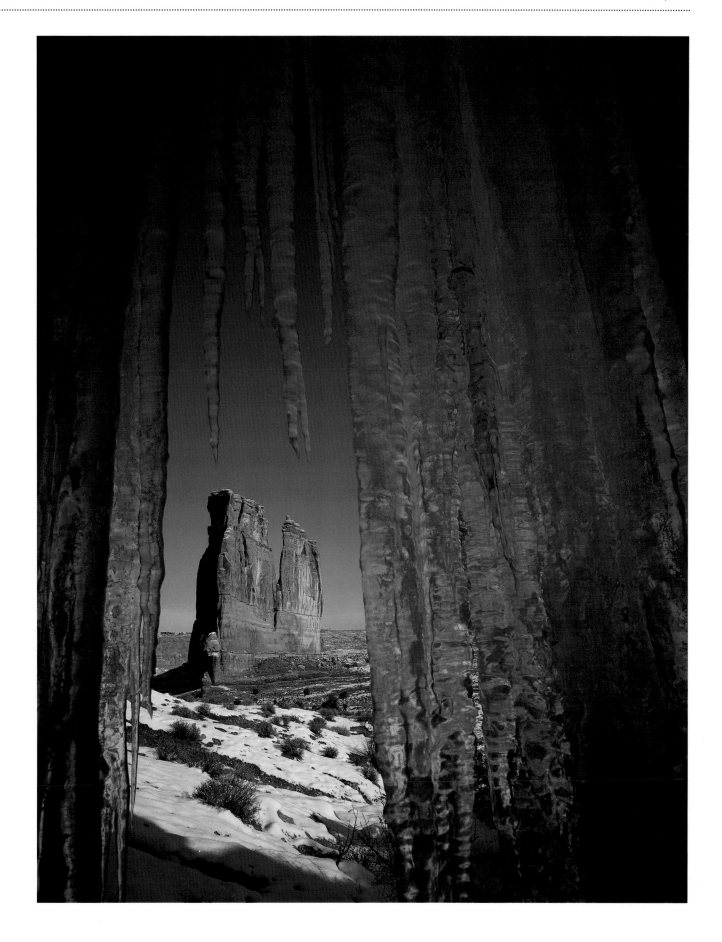

A shortcut to all this focusing and refocusing is to simply tilt the back standard until the near and far areas of the composition look equally out of focus. Then, simply adjust the camera's focusing knob to bring everything into sharp focus. You must *always* check your final adjustments with a loupe. I use the Schneider 4X loupe and prefer the pink-colored model (instead of the traditional black) for its ability *to not get lost!*

One of the classic problems facing the landscape photographer is that while tilts place the entire range from near to far in the same plane of focus, objects in a typical landscape frequently have a nasty habit of not being exactly in that plane. For instance, notice in the photograph of Indian paintbrushes that the foreground flowering paintbrushes are in focus, as is the distant hillside.

The solution is to stop down the lens and increase the apparent depth of field. I've read many books telling me to use the "optimum" *f*-stops for maximum sharpness. That's great and very true; however, in the field, when light is changing and there's an opportunity for a great photograph, I'm going to simply stop down the lens as far the light allows and shoot. Over the years, I've learned that many of my lenses are quite sharp at their minimum *f*-stop (*f*/45), while others that stop down to *f*/64 must never be used at the smallest opening. I've learned that lenses, like people, have unique characteristics.

Bulrushes *(Scirpus sp.)* with flowering paintbrushes *(Castilleja sessiliflora).* Capitol Reef National Park, Utah

Arca-Swiss F-Field camera with Schneider Super-Angulon 75mm lens

A straight plane of focus would run along the ground in the foreground and continue to the horizon. But here, the flowers are 3 feet off the ground and the hills in the background aren't along the same plane either.

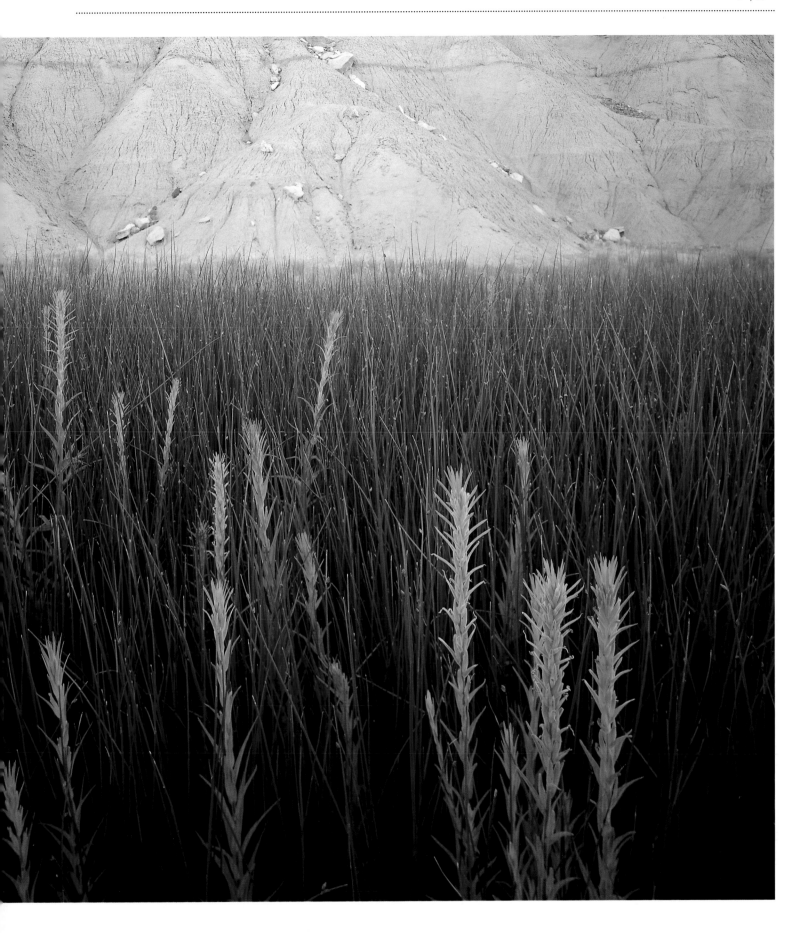

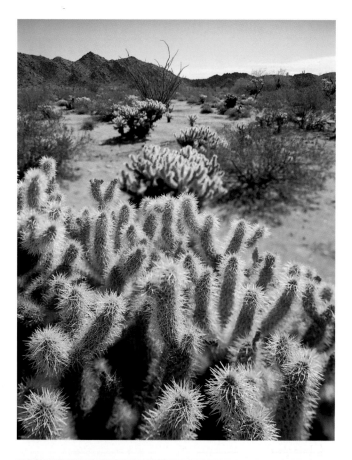

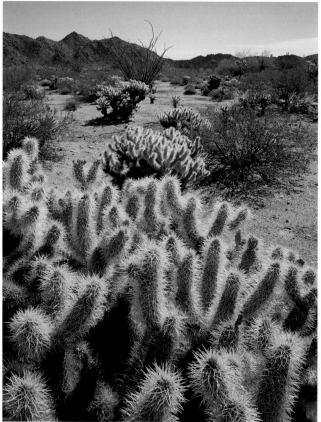

Teddy bear cholla cactus *(Opuntia bigelovii)*. Cabeza Prieta National Wildlife Refuge, Arizona

Arca-Swiss F-Field camera with Schneider Super-Symmar XL 110mm lens at *f*/5.6 (top) and at *f*/45 (bottom)

To take the top picture, I focused on an area of the ground glass about 1 centimeter from the lower edge (the farthest point in the actual scene) and tilted the camera back, bringing the tips of the cholla spines into sharp focus. The base of the plant and the mid-range bushes are out of focus. Stopping the lens way down in the bottom image extended the appearance of sharp focus down to the base of the plants and rendered the entire slope of the hillside in the background sharp, as well. By stopping down, I effectively widened the plane of sharp focus to include the uneven nature of the landscape.

An alternative method to achieve near-to-far focus is to use a camera with an *axis tilt*. My Arca-Swiss F-Field camera with Orbix Micrometric front standard has both a base and an axis tilt on the front standard. The axis tilt allows the lens to be tilted forward and back, centered on its optical axis. Whereas a base tilt changes the relative distance between the film plane and the lens, the axis tilt simply rotates the lens at a fixed distance from the film plane. Therefore, near-to-far focus can be achieved very quickly by simply focusing at the center of the composition (often marked at center on the ground glass/screens) and tilting the lens (on axis) until both near and far areas pop into sharp focus. However, to keep the image centered on the film and to avoid edge fall-off, I raise the rear standard.

When using a back tilt to bring the foreground and background into simultaneous sharp focus, the subject in the foreground becomes exaggerated in size. When small objects such as flowers comprise the foreground, their size increases relative to the background; that's great to emphasize their beauty. However, in situations in which you have a subject that's a perfect circle or perfect geometric shape in the foreground, you wouldn't want that exaggerated foreground look. Your circular subject would become an oval, or a square could become a trapezoid. The solution is to use a front tilt while keeping the rear standard vertical, thereby assuring a faithful reproduction of the subject matter.

However, most situations encountered by the landscape photographer involve irregularly shaped subject matter with emphasis placed on the foreground. For that reason, I'm apt to use a back base tilt most of the time. I must confess that I try to stick to the same movements in an effort to keep things simple and habitual, and thereby avoid mistakes.

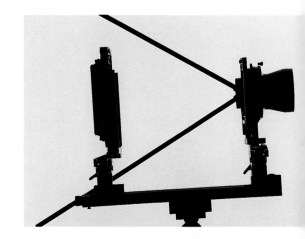

Camera adjustment: front axis tilt

Equipment shown: Arca-Swiss F-Field camera with Orbix Micrometric axis tilt front standard

By tilting on axis, the image is angled upward, off center from the rear standard.

By raising the rear standard, the image coverage remains centered over the rear standard's film back.

Swing

Some situations call for near-to-far focus with the foreground appearing at the right or left of a background at infinity.

Sometimes the subject matter isn't brought into sharp enough focus using either a tilt or a swing. Plants and the landscape in general don't always come into proper alignment by correcting either the vertical or horizontal plane. The solution may be to make corrections in both planes—to employ both swing and tilt movements.

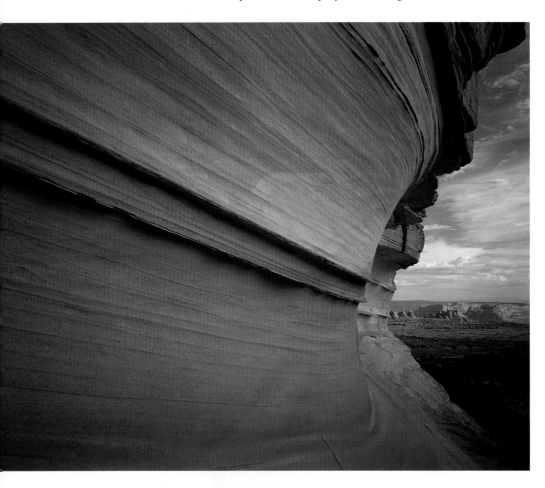

LEFT: Petrified sand dunes with eroded sandstone bands in morning light. Paria Canyon-Vermilion Cliffs Wilderness, Arizona

Arca-Swiss F-Field camera with Schneider Super-Angulon 75mm lens

A rear standard swing kept both the foreground sandstone wall and the distant petrified formations in sharp focus. I followed the same sequence of focusing on the distant object and then swinging the camera back until the foreground was also sharp. You must readjust the focus, check it with a loupe, and repeat the process until both foreground and background are "tack sharp." In this case, the swing is almost always an "on-axis" movement (as long as the rear shift remains centered).

BOTTOM: *Arca-Swiss F-Field camera and wide-angle bellows (viewed from above) with a rear standard swing, bringing both the left side foreground and right side background of the image into sharp focus. The lens is a Schneider 75mm Super-Angulon.*

OPPOSITE: Flowering ocotillo branches (*Fouquieria splendens*) at dawn with the Cabeza Mountains in the background. Cabeza Prieta National Wildlife Refuge, Arizona

Arca-Swiss F-Field camera with Schneider Super-Angulon 75mm lens

To bring everything into sharp focus in this image, I began by bringing the distant objects into sharp focus on the distant right, then tilting the back until the near-central area was sharp, as well. Then I adjusted the overall focus. And finally, by employing a slight swing, I brought the ocotillo flowers at the foreground left into sharp focus, too. One more readjustment of overall focus, and it's done.

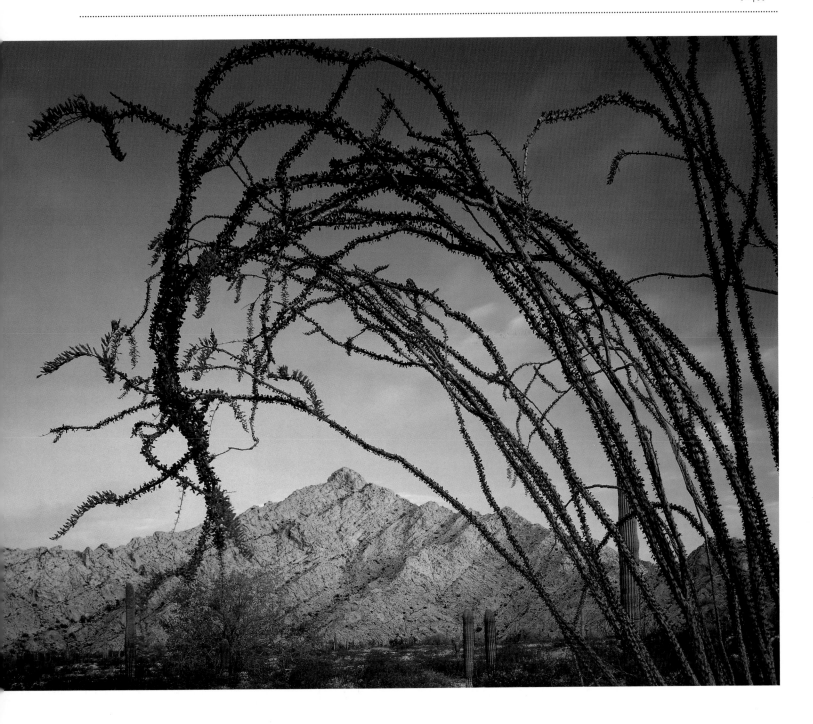

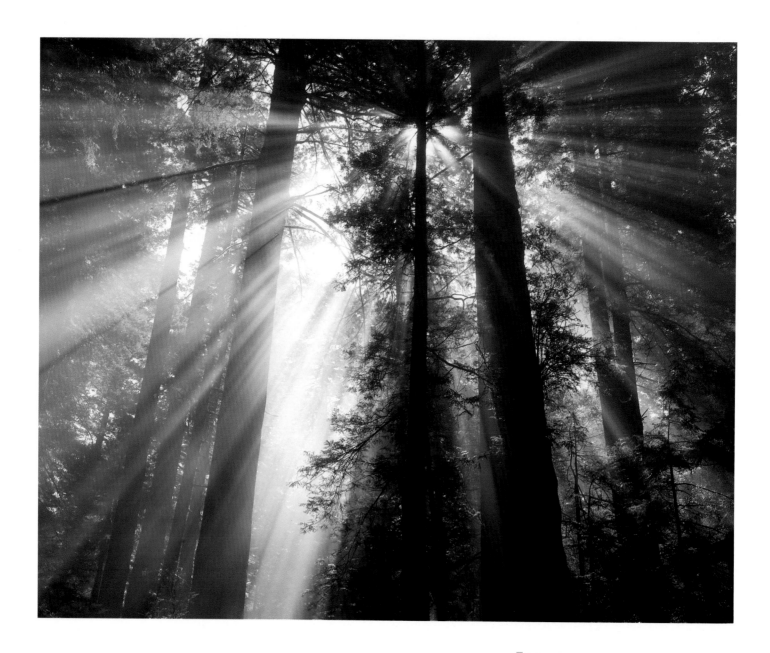

Front Rise

For situations in which I'm aiming the camera up at a tall subject, I employ a *front rise* to keep the vertical lines of the subject parallel to one another and prevent them from converging. Instead of pointing the camera up at the subject, the camera remains level and the lens is raised on the front standard parallel to the film.

Giant redwoods *(Sequoia sempervirens)*. Del Norte Coast Redwoods State Park, California

Arca-Swiss F-Field camera with Schneider Super-Angulon 75mm lens

Without a front rise, the vertical lines of the tall trees all appear to lean.

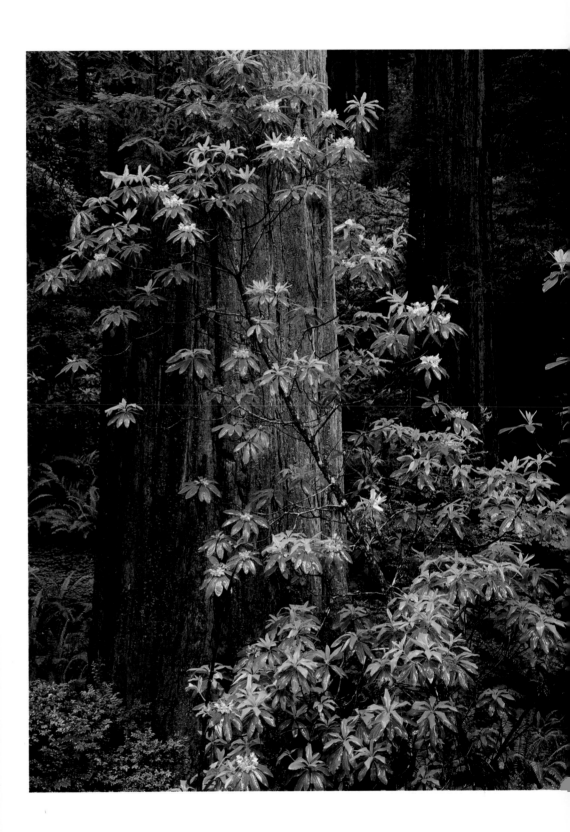

Giant redwoods *(Sequoia sempervirens)*
with flowering rhododendron
(Rhododendron macrophyllum). Del Norte
Coast Redwoods State Park, California

Arca-Swiss F-Field camera
with Schneider Super-Symmar XL
110mm lens

Raising the front standard keeps the tree
trunks vertical.

I level the camera using the spirit levels on the rear standard. Then by loosening the knobs on the front standard, I'm free to raise that standard and the lens until I have the composition I want. For compositions with trees, each tree appears vertical and each trunk is parallel to the next.

When using a front rise, it's crucial that you have a lens with a large image circle. In other words, when you raise the lens, you must not raise the image area outside of the film frame. (See pages 63–93 on lenses for more on this.)

Some photographers believe that the back standard must be absolutely level in every situation. I believe that rules are sometimes made to be broken.

Camera adjustment: front rise (note that the rear standard remains vertical)

Equipment shown: Arca-Swiss F-Field camera

OPPOSITE: Main entrance and façade of San Xavier del Bac with evening sidelighting and edge fall-off. Tucson, Arizona

Arca-Swiss F-Field camera with Schneider Super-Angulon XL 58mm lens

While photographing the Mission San Xavier del Bac, I wanted to capture the entire scrollwork surrounding the entrance, but was limited in how far I could back away by a gated courtyard. My solution was to raise the front standard using the very wide 58mm Super-Angulon XL and knowingly exceed the coverage of the image circle; I would then crop the image later.

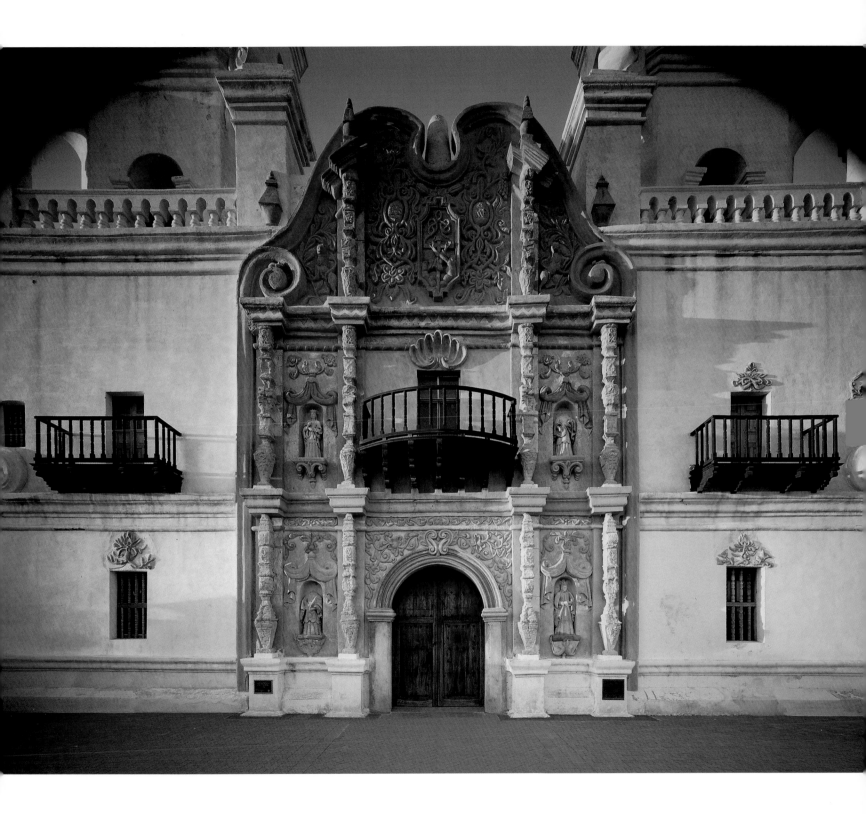

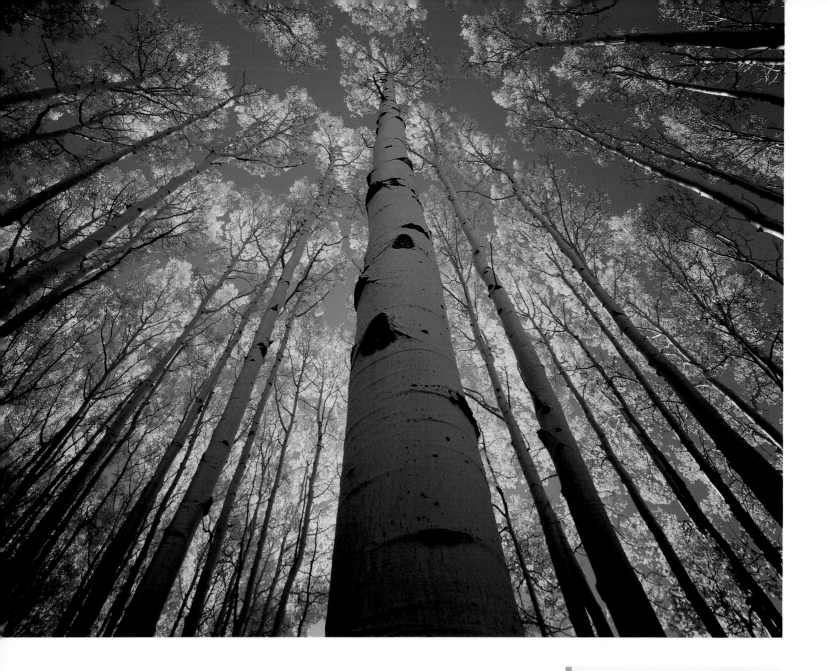

Shift

The Arca-Swiss cameras and most monorail-type cameras have both a front and rear shift adjustment. You can align a subject that's off center to the right or left while maintaining perspective in the same way the rise and fall adjustments are made on the front standard. In other words, the relationship of film to lens slides back and forth to the right or left. You can slide either the front standard with the lens or the back standard where the film is. Architectural photographers use this form of perspective correction frequently. However, for most landscape situations, I believe it's best to leave the shift adjustments set neutral or zeroed. As long as the shift is zeroed, subsequent swing movements will be on axis.

Quaking aspen *(Populus tremuloides)* on Boulder Mountain. Dixie National Forest, Utah

Arca-Swiss F-Field camera with Schneider Super-Angulon 75mm lens

Here, I pointed the camera almost straight up the trunk of this aspen. With no rise in the front standard, I let the converging lines of the tree trunks enhance the composition. I did, however, use a back tilt to keep the foreground trunk in sharp focus.

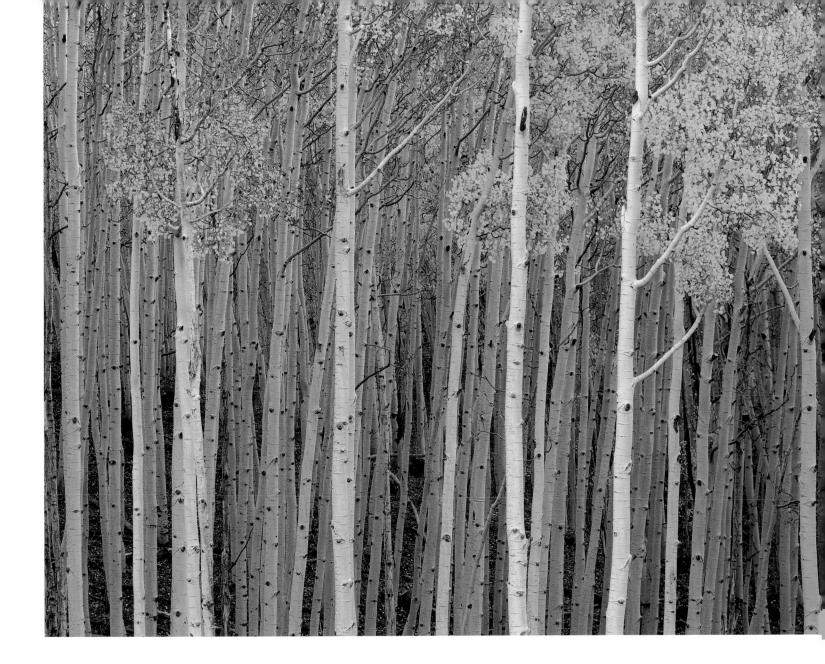

Quaking aspen *(Populus tremuloides)* on Boulder Mountain. Dixie National Forest, Utah

Arca-Swiss F-Field camera with Schneider APO-Tele-Xenar 400mm lens

I also photographed the same stand of aspens with the camera leveled and using a front rise to keep the trees vertical and parallel. This time, I used a 400mm APO-Tele-Xenar lens; the telephoto lens compressed the aspen trunks against each other.

The Arca-Swiss F-Field camera with the Orbix Micrometric front standard employs an axis tilt on the front standard. This feature is desirable in the precise world of architectural photography. That movement is not included on the Wista DX2 and is something I very rarely use while photographing the landscape.

As mentioned in the technical note on page 4, the definitive work on large-format view cameras is Leslie Stroebel's *View Camera Technique* (Focal Press, 1999). I really recommend this book as a must-have technical reference for anyone serious about large-format photography. He expands greatly on all the view camera movements.

Viewing the Ground Glass

I could call this my meditation section. I truly believe that my time under the focusing cloth is essential for me to make strong images. I have several friends who swear that the only way to compose is with a reflex viewer, providing a "right-side-up" image. They just cannot get comfortable seeing things upside down.

When I duck under the focusing cloth, something magical happens. It's like saying good-bye to the outside world. Everything else falls away. I'm left with darkness and this upside-down image. My eyes are free to bore into the scene in front of me. I scan the corners of the frame, ensuring that there are no vacant spaces, no bright areas leading the eye out of the frame. I want to control this frame in front of me, and the inverted image helps slow the process. Elements in the scene are reduced to shapes and

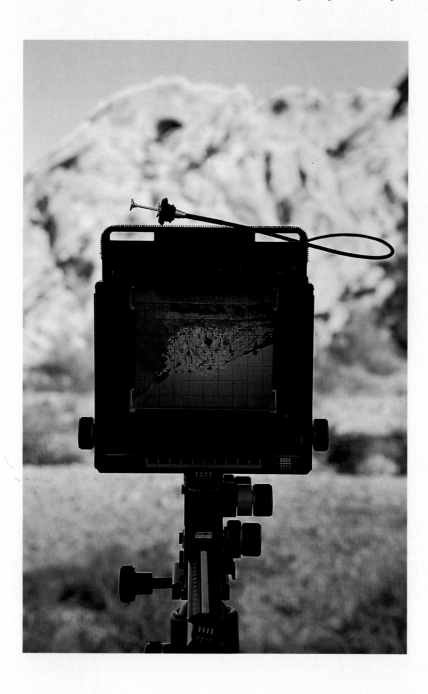

THIS PAGE: *The inverted image on the ground glass.*

OPPOSITE, LEFT: *Occasionally, when I'm in a hurry and the sun suddenly begins to shine directly onto my lens, I quickly attach the compendium lens shade and continue exposing film. My rush to shade the lens without rechecking the ground glass carefully can have devastating effects. Here, you can see the extended compendium lens shade cutting into the image area.*

OPPOSITE, RIGHT: *Under the focusing cloth using my Arca-Swiss F-Field camera with a Schneider APO-Symmar 180mm lens.*

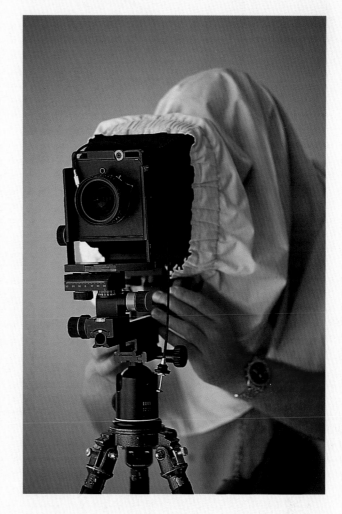

forms. I stop the lens down, darkening the image and further reducing it to shapes and forms. Sometimes I go through all the motions, only to decide I didn't really like the composition. Sometimes I shuttle from composition to composition, wandering but arriving too late at the composition I really want. But, there's always tomorrow.

I prefer a focusing cloth that's white on the outside and black velvet on the inside. The white keeps me somewhat cool under the tyranny of the desert sun, and the velvet lining provides enough friction to prevent the cloth from sliding off my head. I use Velcro to attach the elastic-banded cloth to my cameras. Unfortunately, my cloth is not available commercially. It was designed and sewn by my good friend Terry Bendt.

Besides creating a darkened space in which to see the composition, the cloth supplies enough darkness to allow a careful scanning of the image area with my Schneider 4X loupe. I slowly check the entire frame with the lens wide open and then again as I stop the lens down to the opening I chose for my exposure. Smaller lens openings mean less light on the ground glass, so I try to fold and arrange the cloth to block any light that's still managing to affect my vision. Then I make sure that nothing is cutting into the image. With the lens wide open, I can't see if the lens shade extends into my image area, for example. You should also always check the corners of an image for vignetting (cut-off edges), as well.

When everything is right, I emerge from under the cloth and expose the film. Then I reattach the focusing cloth to recheck the image for any shifts in focus or perspective. I've found that this simple act will catch serious problems in the field (where they can be corrected), instead of at the lab (when it may be too late to fix them)!

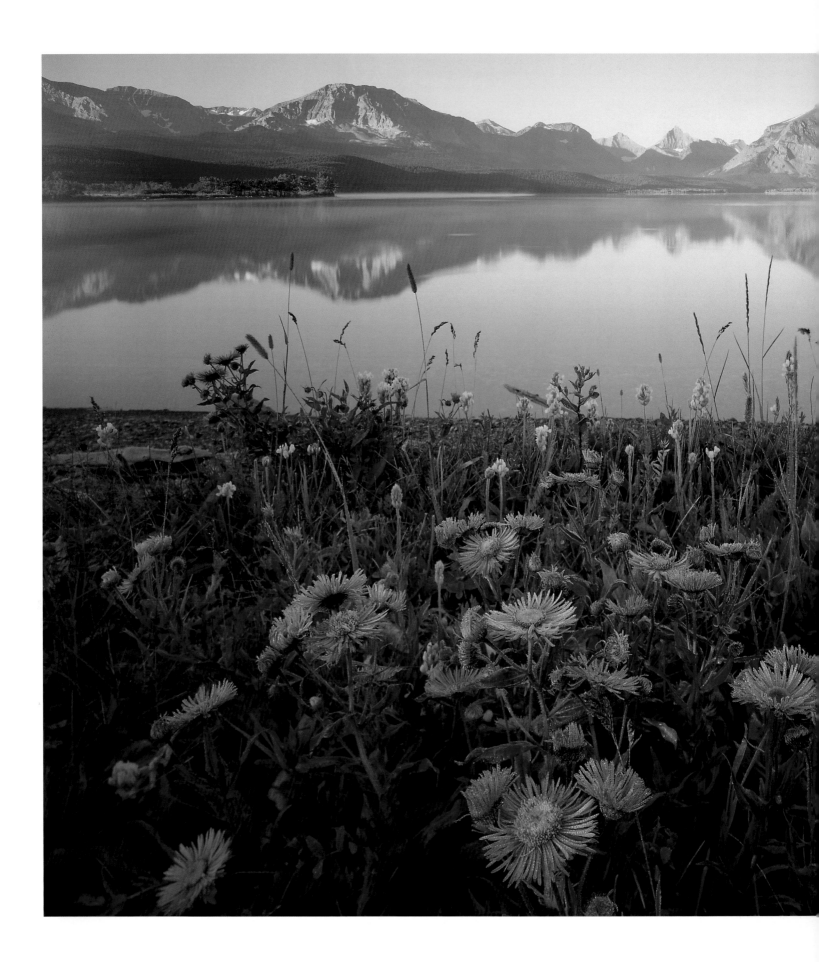

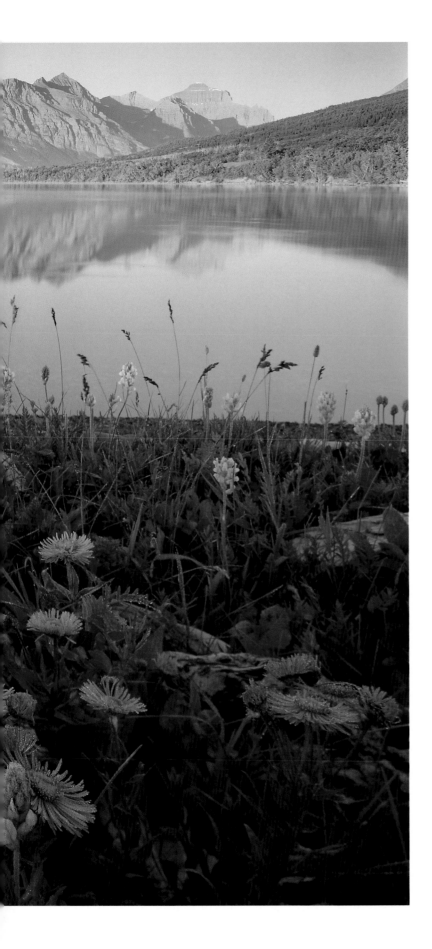

Lenses

Dew-covered, flowering showy fleabone
(*Erigeron speciosus*) in the foreground with
the Lewis mountain range and St. Mary
Lake in the background. Glacier
National Park, Montana

F or the field photographer, there's always a trade-off between carrying heavy huge lenses with huge coverage (image circles) versus small lenses with small image circles that are lighter and therefore easier to carry.

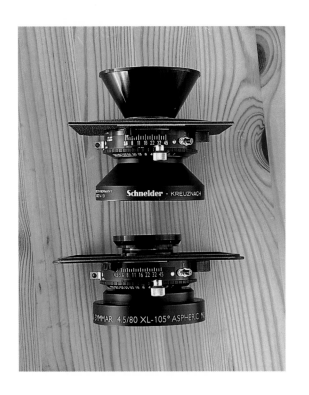

LEFT: *At top is the heavier, larger, more traditional Schneider Super-Angulon 75mm lens. Below is the Schneider aspherical Super-Symmar XL 80mm lens, which has a more compact design.*

OPPOSITE: Saguaro cacti (*Carnegiea gigantea*). Saguaro National Park, Arizona

Arca-Swiss F-Field camera with Schneider Super-Symmar XL 110mm lens

I shot this image looking up at a stand of saguaro cacti using a Schneider Super-Symmar XL 110mm lens. Note how the giant saguaros "lean" in toward each other without the use of a front rise camera adjustment; they don't appear vertical.

An image circle is the actual circular image that the lens projects onto the film. The rectangle within that image circle represents the size of the film and the ground glass. When the image circle is too small, the corners of the image are cut off because the film's area is greater than the image circle. In other words, a 4 x 5 sheet of film is 161mm wide at its widest point (along the corner-to-corner diagonal). A lens needs to project an image circle at least 155mm wide to completely cover the image area on the film. That same image circle becomes larger as you focus closer.

Some lenses project an image area onto the film plane that is much larger than the film area. These lenses allow the photographer to move the lens relative to the film considerably, which in turn affords the photographer a means of correcting perspective and changing the plane of focus. The greater the image circle, the more potential there is for camera movements. The down side to using lenses that offer a larger image area is that they're heavy and bulky.

Recent improvements in lens development have combined light weight with huge coverage by incorporating an aspherical element in their design. The 80mm, 110mm, and 150mm Schneider Super-Symmar XL lenses are all aspherical lenses. Both the 80mm and 110mm lenses are very small and lightweight, offering incredible sharpness while projecting large image circles. The 110mm has become my favorite; it has coverage of 288mm (almost large enough to use with an 8 x 10 sheet of film).

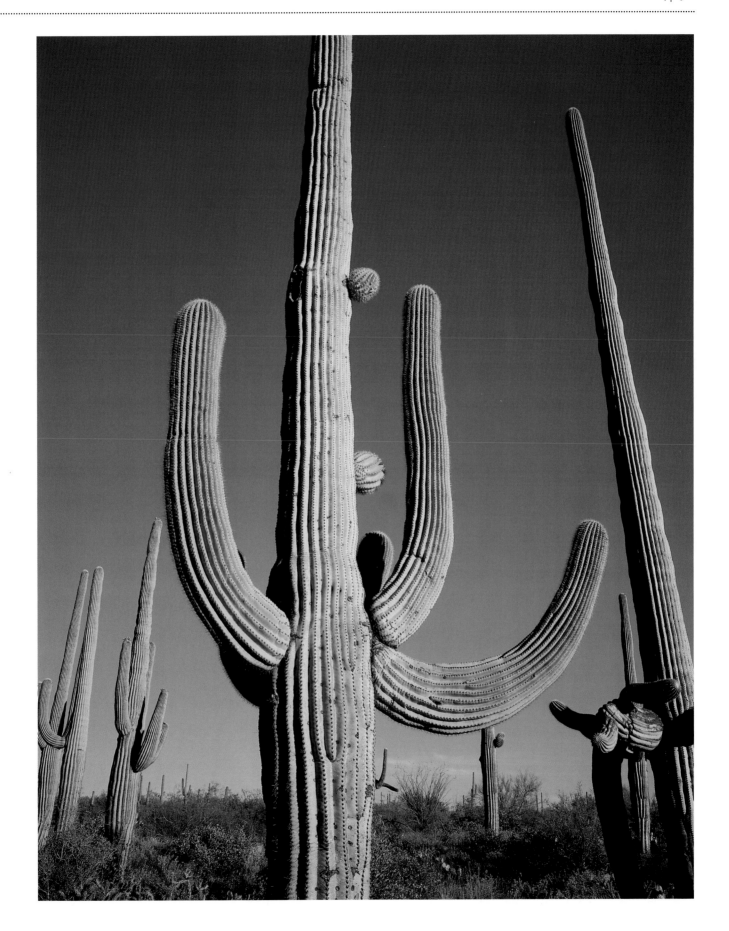

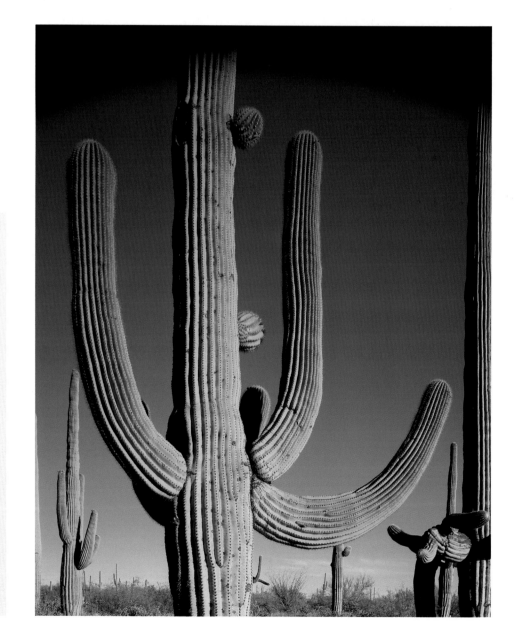

ABOVE: *This view of a Schneider Super-Symmar HM 120mm lens without a bellows shows clearly how the projected image does not cover the entire film area when a front rise is used.*

RIGHT: Saguaro cacti *(Carnegiea gigantea).* Saguaro National Park, Arizona

Arca-Swiss F-Field camera with Schneider APO-Symmar HM 120mm lens

For this image, made with a Schneider APO-Symmar HM 120mm lens and the camera leveled, I raised the front standard to correct the distortion of the cacti and keep their trunks vertical and parallel to one another. Note that I've exceeded the coverage of this lens (with its 211mm image circle) and cut into the image area; the edge of the circle is clearly visible.

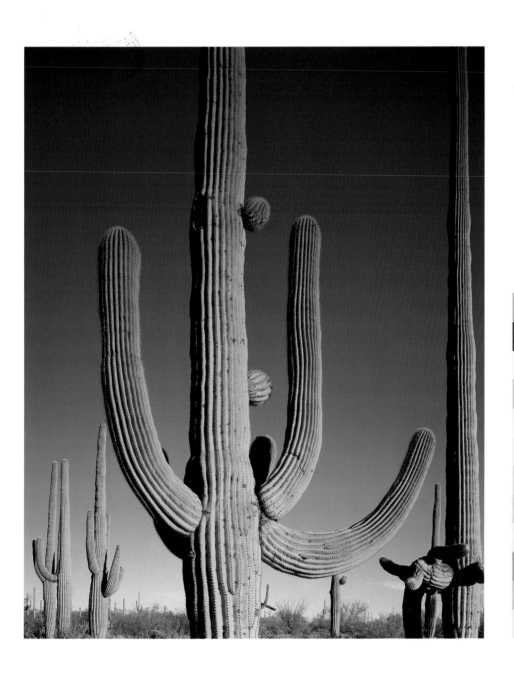

ABOVE: *Without the bellows between this Arca-Swiss F-Field camera and Schneider Super-Symmar XL 110mm lens you can see how the lens' huge image circle projection completely covers the rear standard and film area.*

LEFT: Saguaro cacti *(Carnegiea gigantea)*. Saguaro National Park, Arizona

Arca-Swiss F-Field camera with Schneider Super-Symmar XL 110mm lens

Photographed from the same location but using a Schneider Super-Symmar XL 110mm lens—with its 288mm image circle—the image fills the frame with room to spare.

LEFT: *The projected image is tilted off-center and causes edge fall-off.*

BELOW: Teddy bear cholla cactus (*Opuntia bigelovii*). Cabeza Prieta National Wildlife Refuge, Arizona

Arca-Swiss F-Field camera with Schneider Super-Angulon XL 58mm lens

Using the Super-Angulon XL 58mm lens, I employed a front tilt to increase depth of field. Though using the front tilt gave me the increased depth of field I was after, trying this adjustment with such a small image circle lead, unfortunately, to cut image corners.

Whereas with a front tilt the image goes off center and the chances of the edge of the image circle not completely covering the film increase, with a back tilt the projected image area remains centered on the ground glass. Note: I need to raise the back to accommodate the lens being tilted down and forward.

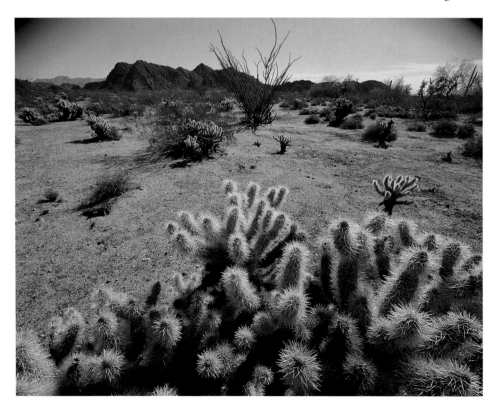

RIGHT: *Here, the projected image area covers the film plane.*

BELOW: Teddy bear cholla cactus *(Opuntia bigelovii)*. Cabeza Prieta National Wildlife Refuge, Arizona

Arca-Swiss F-Field camera with Schneider Super-Angulon XL 58mm lens

This is the same cactus but photographed this time using a back tilt. The image completely covers the frame without the cut corners.

Many lenses have image circles that allow for only a slight amount of movement but offer the effect you need. The extremely wide Schneider Super-Angulon XL 58mm is such a lens. Its smallish 166mm image circle limits its movement potential.

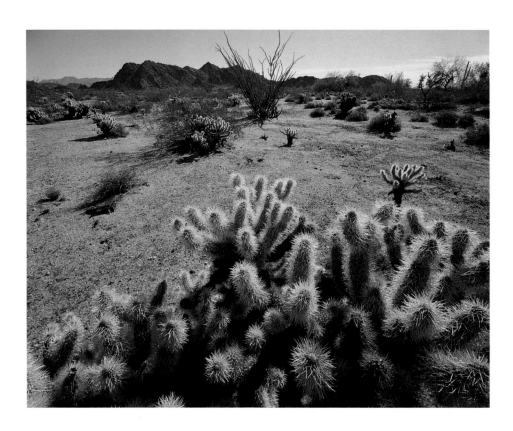

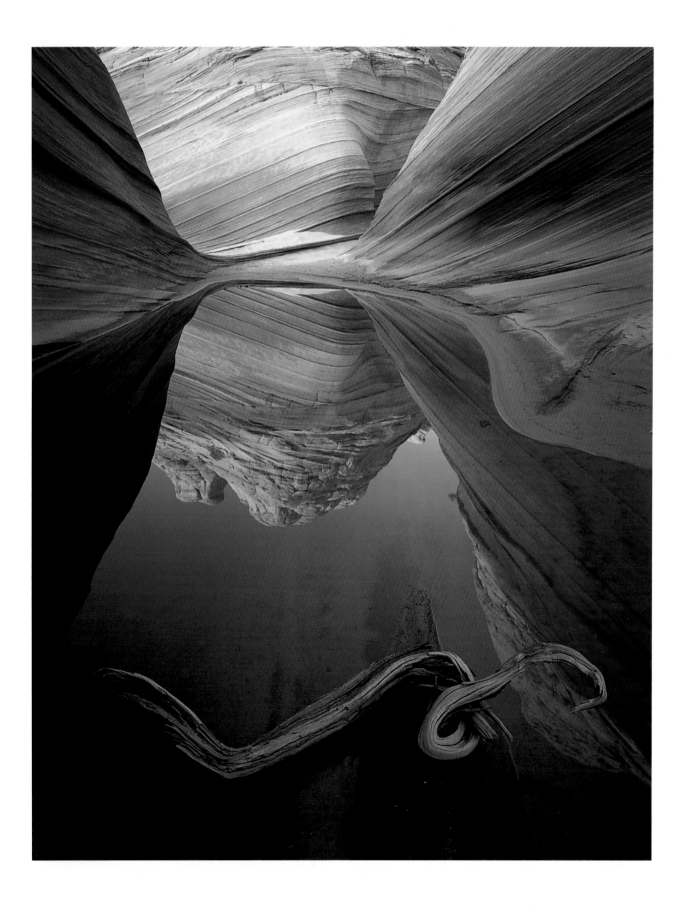

OPPOSITE: Petrified sand dunes and reflection. Paria Canyon-Vermilion Cliffs Wilderness, Arizona

Arca-Swiss FC camera
with Schneider Super-Angulon
75mm lens

Tilting the lens renders everything from the curled root in the foreground to the distant sandstone in sharp focus.

THIS PAGE: *Notes on my Schneider Super-Angulon XL 58mm lens remind me that I should employ a slight fall with this lens. Notations like this are just another way to speed the process and make fewer mistakes.*

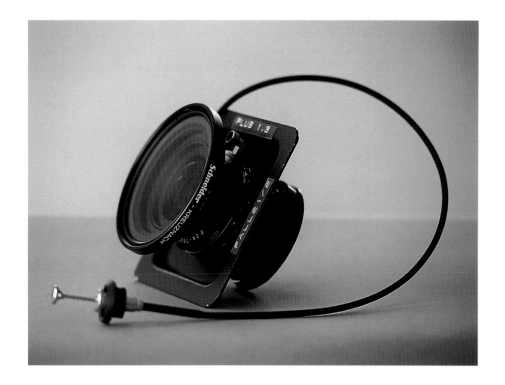

When trying to do a front rise with lenses having smaller image circles, I know that there are limits, and by making several tests, I can learn and record these limits. By exposing some film taken during differing degrees of front rise, I can determine when I exceed the coverage of the image circle. Then, by adding notes to the lens board of that lens, I can readily see the coverage of each lens. The same holds true with extreme wide-angle lenses. As I tilt the back of my camera (see top image on page 69), you can see that the projected image area at the rear standard's base is quite close to the edge of the film's coverage. So, I add notes to that particular lens board reminding me that I can use a slight "fall" with this lens, meaning I can lower this lens when using a back tilt to improve coverage.

Wide-angle lenses bring their own set of problems to large-format photography. They are difficult to view through because they spread the light over a very wide area, and the intensity of the light is concentrated in the center of the focusing screen; as you view the corners, the light falls off, and the edges are darker.

Personally, I like that effect when using my Schneider 75mm Super-Angulon. I can attain the result of a graduated density filter by placing the hotly lit areas near the edge of my composition. I do, however, increase my exposure by 1/3 stop to compensate for the exposure variance over the entire frame. I risk overexposing the foreground and center, but since I often use this lens with a back tilt, the foreground and center portions of the composition can use more exposure due to a slight bellows factor. In other words, the foreground has a greater bellows draw due to the back tilt, while the distant object remains at a minimal bellows draw.

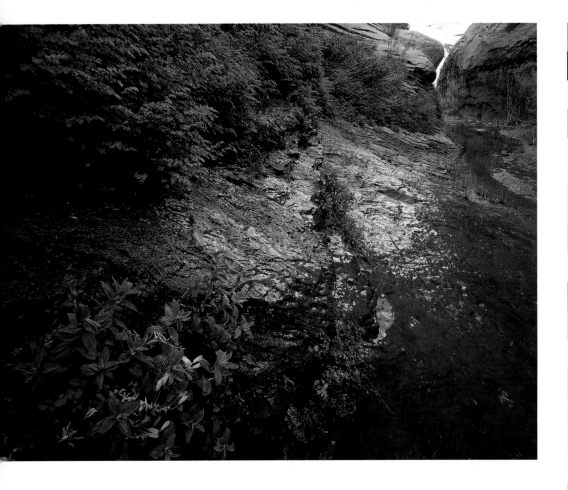

LEFT: Scarlet monkey flowers (*Mimulus cardinalis*) and maidenhair ferns (*Adiantum capillus-veneris*). Glen Canyon National Recreational Area, Escalante Canyon, Utah

Arca-Swiss F-Field camera with Schneider Super-Angulon 75mm lens

An example of grand, wide-angle overview with great depth of field using the 75mm Super-Angulon.

OPPOSITE: Flowering pacific rhododendron (*Rhododendron macrophyllum*) amid redwood (*Sequoia sempervirens*). Del Norte Coast Redwoods State Park, California

Arca-Swiss F-Field camera with Schneider Super-Symmar XL 110mm lens

The Schneider 110mm Super-Symmar XL provides a perspective that's between my very wide Schneider 75mm Super-Angulon and the 180mm APO-Symmar. Its good movement potential allowed me to capture this image in the redwoods with an extreme rise on the front standard.

Focal Lengths My choice in lenses is a carryover from my days as a photojournalist. At that time, I would carry two Leicas—one with a 21mm lens and one with a 35mm lens—dangling from my neck. On one shoulder was a Nikon with an 85mm lens, and on the other, a Nikon with a 180mm lens. I learned to compose with those "windows" imprinted in my brain.

Today, I still use the same approximate "windows." For wide-angle photography, or when I'm looking for that grand overview, I've replaced the 21mm with a Schneider Super-Angulon 75mm. I use it to emphasize the foreground while maintaining incredible depth of field. Its wide perspective is useful for creative compositions with bold lines.

My small format 35mm lens has turned into a Schneider Super-Symmar XL 110mm. With this lens, I can achieve many of the same effects offered by the wider 75mm lens. However, I choose this lens when I'm trying to emphasize the background as well as the foreground. It really shines when situations demand a front rise movement.

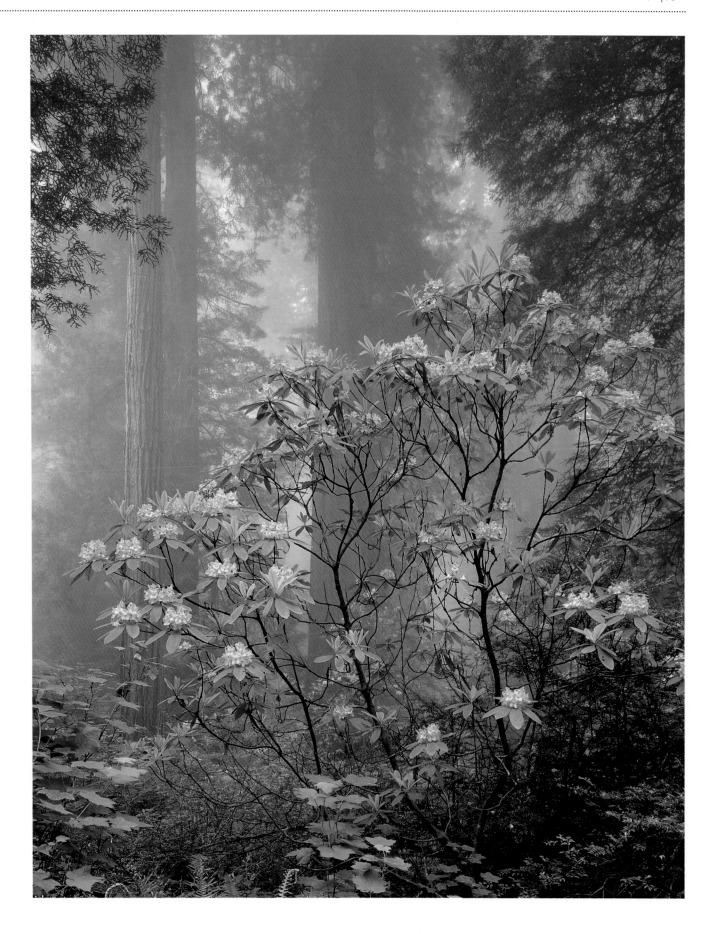

My Nikon's 85mm lens is now the Schneider 180mm APO-Symmar. This is my utility lens that I use for scenes in which I want both the foreground and background in sharp focus, with an equal emphasis on both. It also has great movement potential with its large 263mm image circle. I use it for close-ups, too.

The Nikon 180mm lens from my photojournalism days has become both my Schneider 270mm G-Claron and my Schneider 400mm APO-Tele-Xenar HM. These are lenses I like to use to stack things up—to compress the foreground against the background or to emphasize the background.

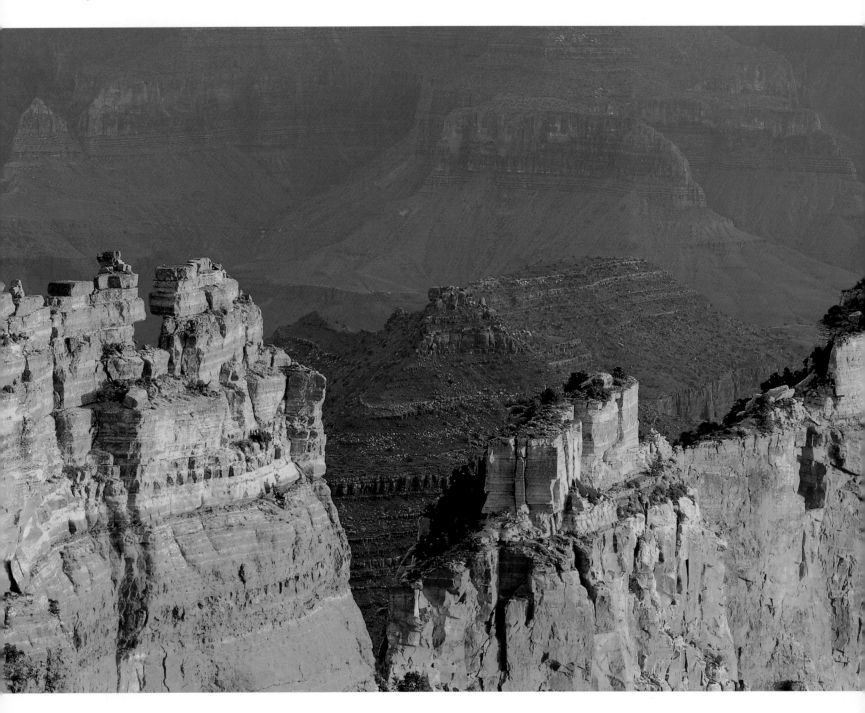

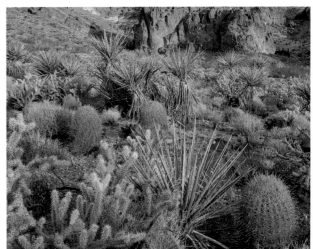

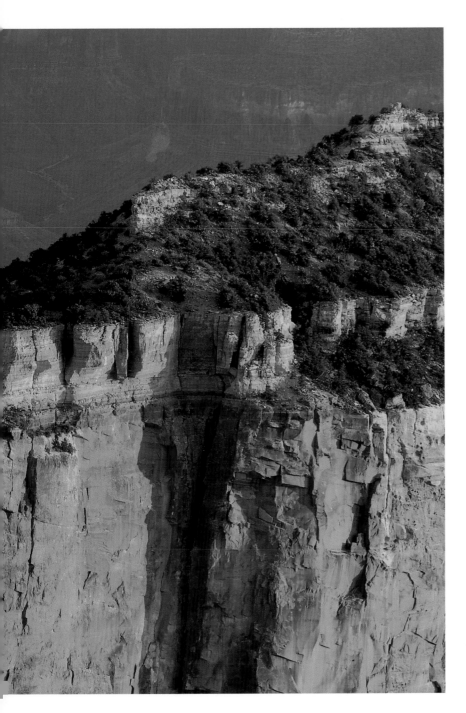

ABOVE: Barrel cacti (*Ferocactus acanthodes var. lecontei*), Mojave yucca (*Yucca schidigera*), and cane cholla (*Opuntia acanthocarpa var. coloradensis*) at dawn. Mojave National Preserve, California

Arca-Swiss F-Field camera with Schneider APO-Symmar 180mm lens

Here, my 180mm APO-Symmar was the perfect choice. I wanted to show the detail in the foreground, yet also emphasize the cliffs in the distance.

LEFT: Cliffs of Cape Royal with the South Rim in the background at sunset. Grand Canyon National Park, Arizona

Arca-Swiss F-Field camera with Schneider APO-Tele-Xenar HM 400mm lens

My 400mm APO-Tele-Xenar HM is my choice when I need to really stack or compress distance between ridgelines, as with this 6x12 (cm) panoramic-format Grand Canyon image.

Telephoto lenses can "slice" into a scene, removing extraneous distractions to produce tightly cropped compositions. Shooting into the sun is also an area in which telephoto and long focal-length lenses excel. With a lens shade in place, preventing lens flare, these lenses are ideal for creating dramatic rim-lit images.

This selection of focal lengths works extremely well for the way I see. It's a bag of tools that enables me to respond to most photographic situations in an effective way. You may have an entirely different way of seeing and therefore need a totally different set of lenses. Trust your own vision and your own personal style.

I also have what I call specialty lenses, which I carry with me but use only in special situations. These are the Schneider 58mm Super-Angulon XL, the Schneider 120mm Macro-Symmar HM, and the Nikkor 720mm ED telephoto lenses. Sometimes the Schneider 75mm Super-Angulon just isn't wide enough, or the design in the foreground is so unique that I really want to maximize its impact. That's when I use the 58mm Super-Angulon XL. I use it sparingly because of its limited movement potential, but when I'm after a very dramatic image, this is one of the lenses I turn to.

When tiny details are what I'm after and an extreme close-up is called for, I'm apt to use my Schneider 120mm Macro-Symmar HM lens. This applies to close-up situations in which the area I'm photographing is approximately between the 1:4 ratio and the 4:1 ratio—when the subject area is either 4 times the size of a 4 x 5 sheet of film, or 1/4 the film's size.

The 720mm ED Nikkor telephoto lens is my choice for maximum compression of a scene, for example to emphasize the sun or moon's size relative to the surrounding landscape.

When you carry a selection of lenses, I strongly believe you should keep things simple. There are so many variables in large-format work. With a monorail view camera, there are twenty different ways to affect an image. Each knob must be locked down in order to ensure a successful image. To this day, I still manage to forget to lock all the appropriate control knobs. So, if you're constantly fiddling with ten different lenses, you may never have time to photograph.

A good personal exercise is to use only one lens. Photograph everything with that lens. Try it with all possible camera adjustments. Use it for close-ups and distant scenes until you are totally comfortable with it. Then move on to the next lens. Do this with each lens in turn, until you've established a degree of familiarity with your entire range of lenses. Your photographic successes will be directly proportionate to the degree of familiarity you have with your equipment.

Many field photographers prefer to use "process," or flat, field lenses because of their light weight. They're generally slower ($f/9.0$) than more traditional $f/5.6$ or $f/4.5$ lenses, but the weight saved is substantial. Examples are Schneider's G-Claron,

Nikon's M series, Fujinon A series, and Rodenstock's APO-Ronar series. Many of these lenses have smaller image circles, so if large movements are your priority, they may not be for you. However, they're quite sharp and perform well when stopped down. Minimum apertures are frequently as small as $f/90$ or $f/128$. These lenses will peel pounds from your pack! I like focal lengths in the 180mm to 305mm range.

Telephoto lenses allow the use of a long focal length with less bellows than the focal length would suggest. For example, my 400mm Schneider APO-Tele-Xenar HM has a flange focal length (length from shutter to film) of only 285mm. This allows the use of long lenses without the need of a very long bellows.

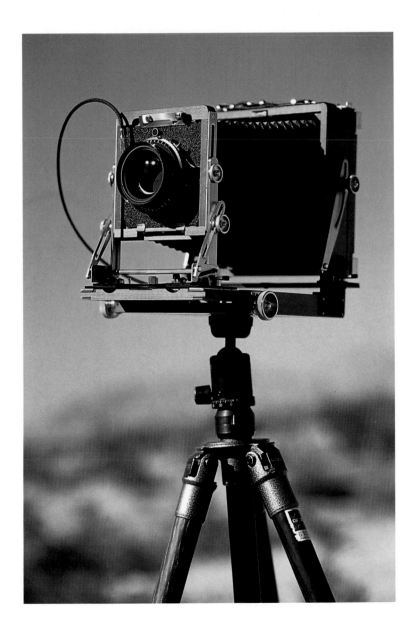

Wista DX 2 cherry-wood field camera with a Schneider G-Claron 270mm lens (a process lens that stops down to $f/90$), mounted on a lightweight Gitzo carbon fiber tripod.

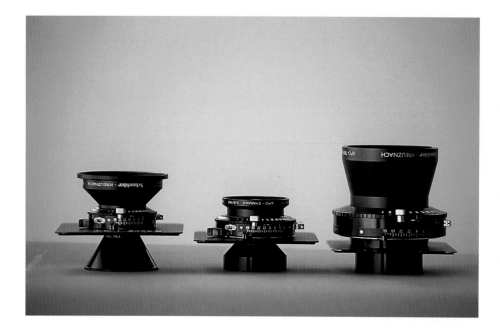

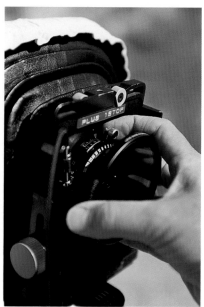

Lenses are mounted into leaf-type shutters that come in three basic sizes: 0, 1, and 3. In the weight-conscious world of field photography, small and light are best. So, I tend to prefer the 0 and 1 shutters. Besides being light in weight, they're also very smooth and vibration free, allowing the use of lighter tripods. The larger 3 shutter is sometimes the only choice for really large lenses, but its large shutter mechanism can vibrate the entire lens, so strong, stable support is critical. If you're going light, leave the number 3 at home.

The Arca-Swiss F-Field 4 x 5 camera comes with a tapered bellows (similar to field cameras) that enables me to use the lighter and smaller lens boards. I favor the flat lens boards as opposed to the recessed boards in every case except for with my 58mm lens; its short focal length just won't permit me to use a flat lens board. I feel that using recessed boards is difficult with my large fingers. The last thing I want to be doing when I'm hurriedly trying to capture changing light is fumbling with lens controls. Ease and simplicity spell success.

Each of my lenses has its own cable release attached. I know this runs counter to my constant harping about being weight conscious. However, I've found that being able to simply grab a lens that's ready to use immeasurably speeds the setting-up process. For me, the payoff justifies the weight. Once I was hiking in a mountain range with my camera set up and mounted on my tripod (something you should never do, because cameras have a nasty habit of coming loose!). I moved from one potential photo opportunity to another for about an hour. Finally, I located the "perfect" composition. But, as I began to set up, I noticed my cable release was gone. I spent the next half an hour jogging my circuitous route, searching for the cable release. The moral of the story?: Keep a cable release mounted to *each lens!*

LEFT: *Examples of three shutter sizes, from left: 0 shutter with Schneider 75mm Super-Angulon lens, 1 shutter with Schneider 180mm APO-Symmar lens, and 3 shutter with Schneider 400mm APO-Tele-Xenar HM lens.*

ABOVE: *My not-too-delicate fingers at the f-stop control on my Schneider Super-Angulon XL 58mm lens.*

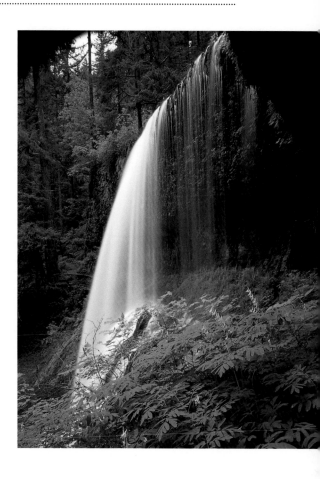

When choosing a cable release, pick one that's long and supple enough not to pass vibrations back to the camera. With one hand, I try to maintain a loose arch in the cable to make sure no movement is transmitted to the camera, while the other hand actually trips the shutter.

Viewing Through Lenses

Bright focusing screens with fresnel lenses that spread the light evenly are available on most, but not all, major view cameras. Before you buy equipment, try as many different camera brands with different focal length lenses. Make sure you pick the camera that works best with the lenses you favor. Wide-angle lenses can be particularly difficult to use, due to the light fall-off in the corners.

Extra time spent carefully "louping" every corner of the ground glass when using a wide-angle lens will be time well spent. Stop the lens down and check carefully into each corner to make sure you have complete image coverage over the entire ground glass. I also recheck my composition when I'm finished photographing, to make sure nothing has moved.

Finally, when I'm using the wide-angle lenses in particular and any lens in general, I *always* check the front element or filter for particles of dust. Some years ago, I had photographed an absolutely fantastic scene that required a large section of clear blue sky for the composition to work. There, in the middle of the even-toned, blue sky was a dark spot. At first I thought it was bad processing; I simply blamed it on the lab. The fault, however, was mine; I forgot to check the front of my 75mm lens that, when stopped down to $f/45$, will do a great job even of recording dust on the front element!

Middle North Falls with big leaf maples (*Acer macrophyllum*) in the background and flowering Sierra corydalis (*Corydalis caseana*) in the foreground. Silver Falls State Park, Oregon

Arca-Swiss F-Field camera with Schneider Super-Angulon 75mm lens

In the darkness of this forest, I managed to miss the cut-off corner at the upper left in this image. Luckily, it matches the cliff shadow at the upper right! Even the pros make mistakes.

Which Lens?

My subject dictates my choice of lens. Different lenses are necessary depending on whether I'm choosing to relate to the foreground or the background; if tiny details are important; if the angle of light demands a certain focal length; or sometimes it's just a matter of "what if"—wanting to try something different, using a lens to create a composition that's unexpected. Surprise situations frequently yield my strongest images.

Saguaro cactus *(Carnegiea gigantea)* with Sand Tank Mountains in the background. Sonoran Desert National Monument, Arizona

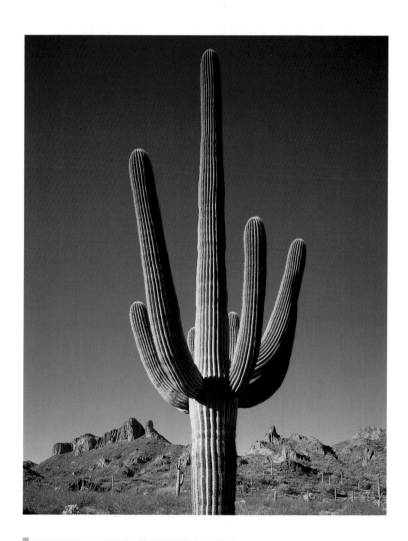

Arca-Swiss F-Field camera with Schneider Super-Symmar XL 110mm lens

My first inclination was to shoot the obvious, showing the whole saguaro cactus using my Super-Symmar 110mm lens. (Note: All images here shown at actual 4 x 5 transparency size.)

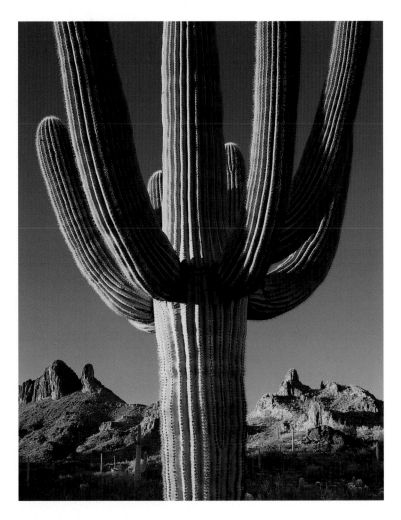

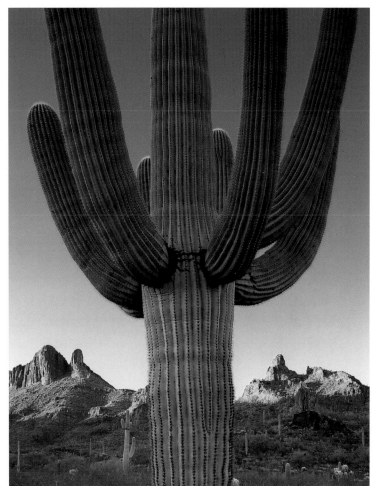

**Arca-Swiss F-Field camera
with Schneider APO-Symmar
180mm lens**

*I then switched to my 180mm APO-Symmar
to tighten the composition and increase the rela-
tive size of the distant mountains. Furthermore,
I used a warm polarizing filter to add boldness
to the cactus against the blue sky.*

*Finally, I waited until the light disappeared
from the foreground and only lit the distant
peaks. Using a polarizing filter for impact, I
then exposed film with and without light on
the saguaro.*

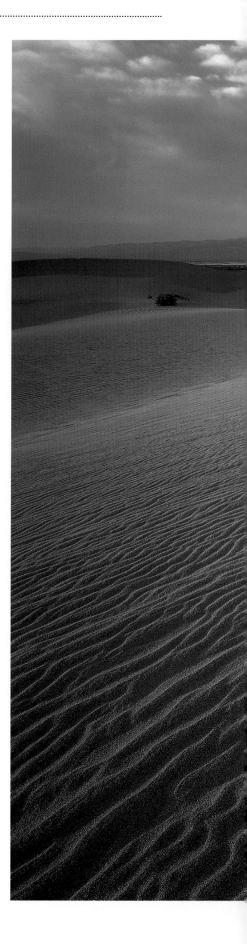

Some subjects have a very strong design element in the foreground that must be emphasized. For these, I choose a Schneider 75mm Super-Angulon wide-angle lens. Others need to have the background brought in closer and, therefore, call for a telephoto or long focal length lens.

The vast open country of the American Southwest sometimes dictates my choice of lens. I'm apt to use a wide-angle lens to show the foreground in a grand landscape under a boundless sky. However, in discussing lens choices with landscape photographers from forested regions, I've found that they favor a normal-to-tele-photo focal length. Quite the opposite from showing the entire landscape, the longer focal length lenses allow them to isolate details or sections of the scene, emphasizing the "closed-in" feeling under the forest's canopy. Either way, our vision seems to be shaped by the land.

Mesquite Flats sand dunes at sunset with Grapevine Mountains in the background. Death Valley National Park, California

Arca-Swiss F-Field camera with Schneider Super-Angulon 75mm lens

The 75mm Super-Angulon lens accentuated the sand dune patterns.

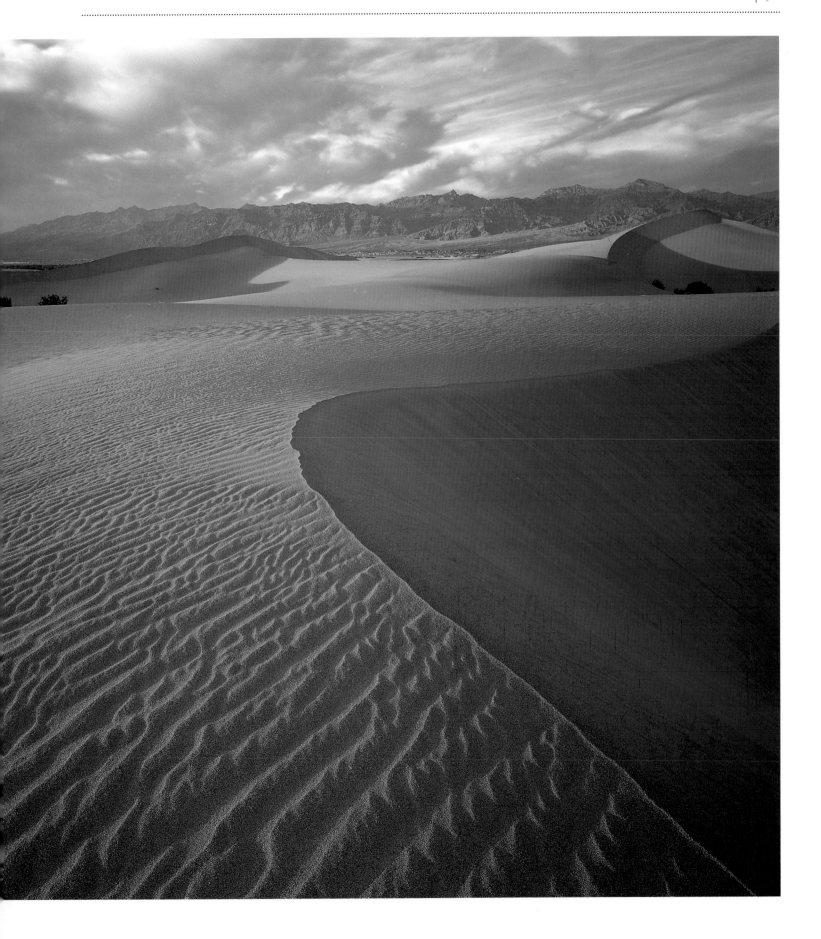

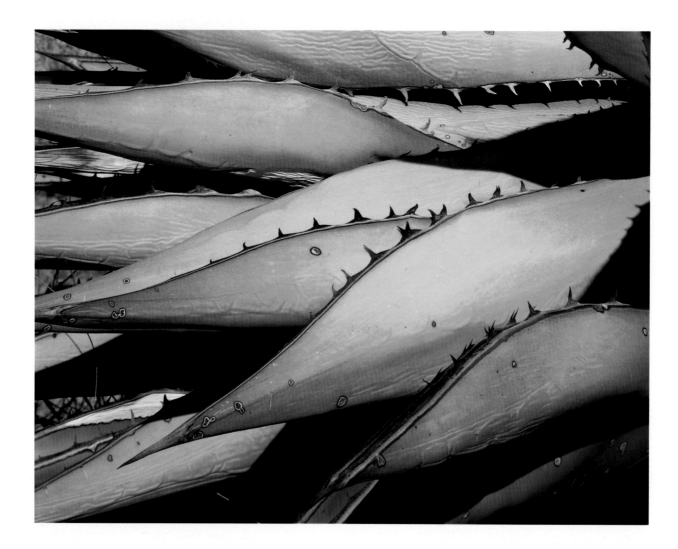

Agave leaves colored and wrinkled by sunlight. Baja, Sierra San Borja, Baja California, Mexico

Arca-Swiss F-Field camera with Schneider APO-Tele-Xenar HM 400mm lens

Here I used a 400mm telephoto lens to isolate this dying agave plant. With the telephoto lens, I can dissect the landscape and select a single plant on which to focus. I can also compress the leaves of an individual plant, "flattening" them one against another to emphasize the details and design.

OPPOSITE: Grand Canyon formations. North Rim, Grand Canyon National Park, Arizona

Arca-Swiss F-Field camera with Schneider APO-Tele-Xenar HM 400mm lens

For this image, I selected a 400mm telephoto lens to give greater emphasis to the background. The lens compressed the cliffs against one another, effectively layering the warm sunlit areas and cool shadows.

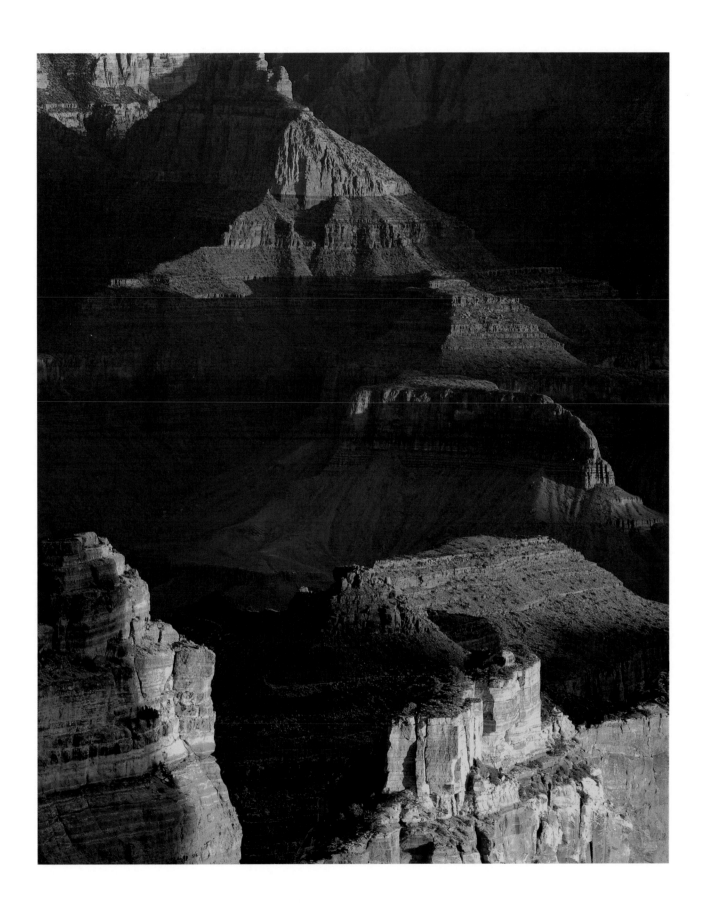

TOP: *An Arca-Swiss F-Field camera mounted, centered and balanced, on an Arca-Swiss B1 Monoball head.*

BOTTOM: *The underside of my Wista DX2 camera with its threaded tripod holes spaced for different focal length lenses.*

Lens Support: Tripods Large-format image quality often suffers from vibration and lack of an adequate platform. When photographers complain that their lenses aren't sharp, I immediately suspect camera movement.

I once observed a photo workshop in progress and was amazed to see what little concern the photographers had for the way they mounted their cameras to their tripods. I watched in horror as they timed off long exposures with 35mm cameras screwed tightly to the tripod heads; they attached their cameras to their tripods, mounted huge telephoto lenses, and in the process, converted their stable platforms into giant, vibrating tuning forks. The result of this was constant camera movement! It can all be avoided by simply balancing the camera over the tripod. In this case, these photographers should have mounted their *lenses*—not their cameras—to their tripods.

The same is true for large-format photography. Keep your camera balanced over the tripod. With the Arca-Swiss camera, I simply loosen the mounting tripod block and position it in a way that keeps the camera balanced. The Wista DX2 camera, however, is a different story. While it came with two different mounting positions, I

felt that I needed a third tripod mount for situations when the bellows was nearly fully extended. Joe Wojcich of Tempe Camera, near Phoenix, Arizona, installed the additional mount, allowing me to keep the camera balanced when using longer lenses.

Gitzo tripods have been my choice since my days as a photojournalist, primarily because they can take a terrific beating. I've never had one "seize up" from granular particles, like sand, either. I use the very light carbon-fiber Mountaineer tripod while backpacking with my Wista camera. This very lightweight tripod is my choice strictly for its lightness. Its stability is good when conditions are perfect; however, I don't use it in the wind. In addition, I use it only with my Wista DX2 camera and make sure the camera is balanced on the lightweight Kaiser ball head. This tripod/ball head combination, together with the Wista, lightens my pack by a whopping six pounds! But, in this situation, I am trading stability for less weight.

I use the metal Gitzo Model 241 tripod as my main tripod. I use the heavier Gitzo Model 341 for situations involving long lenses or situations when a more stable platform is required. Windy conditions, close-up situations, or times when I'm in need of extra elevation all require extra stability.

I like these models because they have an interchangeable "pie plate" mount that allows the tripod legs to be splayed out flat to the ground, for a very low-angle position. You can also replace the pie plate with the standard center column for more elevation. Generally, I avoid center columns, choosing stability instead of height.

Working with tripods in weather that runs the gamut of extreme heat to subzero cold requires both insulation and a non-slip covering for the tripod legs. My solution is quite simple. I use old bicycle inner tubes. By applying a thin layer of hair spray (for lubrication), I slide cut sections of inner tubes over the largest, uppermost leg sections. When the hair spray dries, it acts as an adhesive. Note: You must remove the ball head and the lower leg sections to avoid any excess hair spray from jamming the controls! Once the tubes are in place, sponge the exterior down with water and you're ready to go.

This is the Gitzo Model 341 Interpro tripod with Kirk Support stabilizing my Arca-Swiss F-Field camera and large 400mm Schneider APO-Tele-Xenar HM lens. Note that the lens is centered over the tripod head, providing more stability and minimizing shutter vibrations, while the Kirk bracket supports the back. This is my tripod of choice for long lens work, operating in the wind, or times when I need to use the large 3 shutter (see page 78). The vibration from the 3 is quite noticeable, especially when shutter speeds are in the 1-second to 1/15-sec. range. On longer exposures, there's enough time for the vibration to stop.

The Arca-Swiss Monoball head is my choice for both metal Gitzo tripod models. People either love or hate their ball heads. Ball heads have the advantage of being very quick to use; however, they also are more difficult to align for the exacting movements that some photographers prefer—a 3-way pan/tilt tripod head that employs separate knobs to control vertical, horizontal, and panning movements is often their choice. You can level one axis at a time: Level the vertical axis and lock it down, and then you're free to level the horizontal without affecting the vertical. With my Arca-Swiss Monoball head, I have to level the camera on both planes at one time. This can be very difficult, but over the years I've found that the speed afforded in setting up my camera outweighs the inherent difficulties.

ABOVE: *Three sizes of Gitzo tripods: the carbon-fiber Mountaineer (the smallest), the Model 241 (the medium-sized one), and the Model 341 Interpro (the largest).*

RIGHT: *With its legs splayed out, the Gitzo Model 241 enables a low-angle viewpoint. Note: The legs are covered by bicycle inner tubes both to protect them and to protect my hands from them, as they get ice cold.*

OPPOSITE: Little Colorado River with partially submerged boulders. Grand Canyon National Park, Arizona

Arca-Swiss F-Field camera with Schneider Super-Angulon 75mm lens

On one photography workshop, I arrived at the Little Colorado River in the Grand Canyon just as the cliffs behind me began to catch the first light. Several students and I scrambled along the rock terraces trying to find a quick composition, and as luck would have it, I located several submerged and half-submerged boulders in the turquoise waters. They anchored my foreground composition, while an incredible band of light struck the background cliffs. In less than a minute, I had my camera mounted, and the lens selected, mounted, and focused. I managed to expose just six sheets of film before the light vanished. I simply could not have captured this image without the speed afforded by a quick-mount ball head.

My Arca-Swiss Monoball head uses a quick-release plate mount to secure the camera to the tripod. The quick-release mount makes my job much easier. By merely setting the camera atop the quick-release platform and tightening a single knob, I can be ready to shoot in seconds. With fleeting light, sometimes that's all you have.

Arca-Swiss, Foba, Kirk, Linhof, and Gitzo all make fine ball heads with quick-release mounts. You call also buy add-on quick-release plates to modify your standard screw-in mount. The Arca-Swiss monorail mounting blocks are machined to fit onto Monoball quick release heads. When using my Wista camera, however, I avoid the quick-release and associated mounting plates and instead use the standard screw-in mount simply to carry less weight.

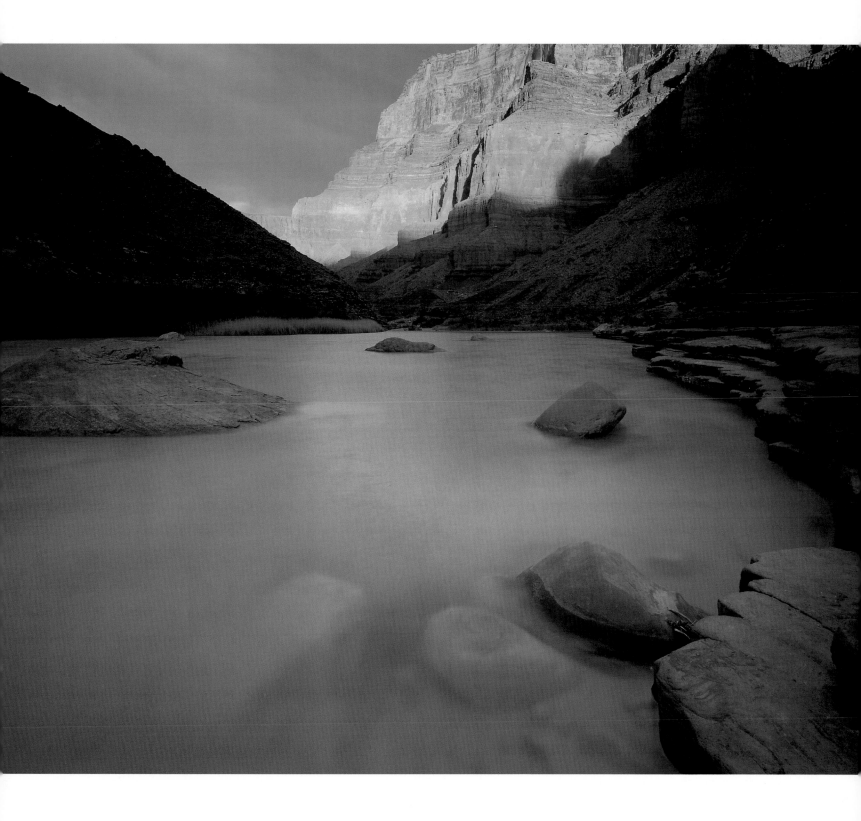

Close-Ups

I've always had trouble doing close-ups. There's all the bellows, acting like a sail, vulnerable to wind and vibrations. You must consider "bellows factor" (see below) affecting exposure, and furthermore, you'll need to recompose each time you move the tripod.

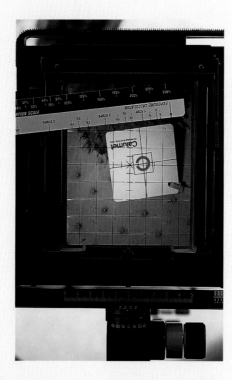

When subjects are very close, the need to extend the bellows while focusing increases. As the length of the bellows (the distance between the lens and the film plane) becomes greater, there is a fall-off of light reaching the film. You must, therefore, compensate by increasing either the exposure times or increasing the light transmitted by using a larger *f*-stop.

More advance planning on my part has made close-up photography much less of a chore. First, I bought a bellows-factor device known as an Exposure Calculator from Calumet Photo in Chicago. It's quite simple: a scale and a target. You place the target in the scene you're photographing and measure that target on the ground glass to determine the proper bellows factor.

THIS PAGE, LEFT: *The target on the subject, a cactus pad.*

THIS PAGE, RIGHT: *Measuring the target on the ground glass.*

OPPOSITE: Santa Rita prickly pear cactus (*Opuntia violacea*) dotted with raindrops. Santa Rita Mountains, Coronado National Forest, Arizona

Arca-Swiss F-Field camera with Schneider Macro-Symmar HM 120mm lens

The finished image.

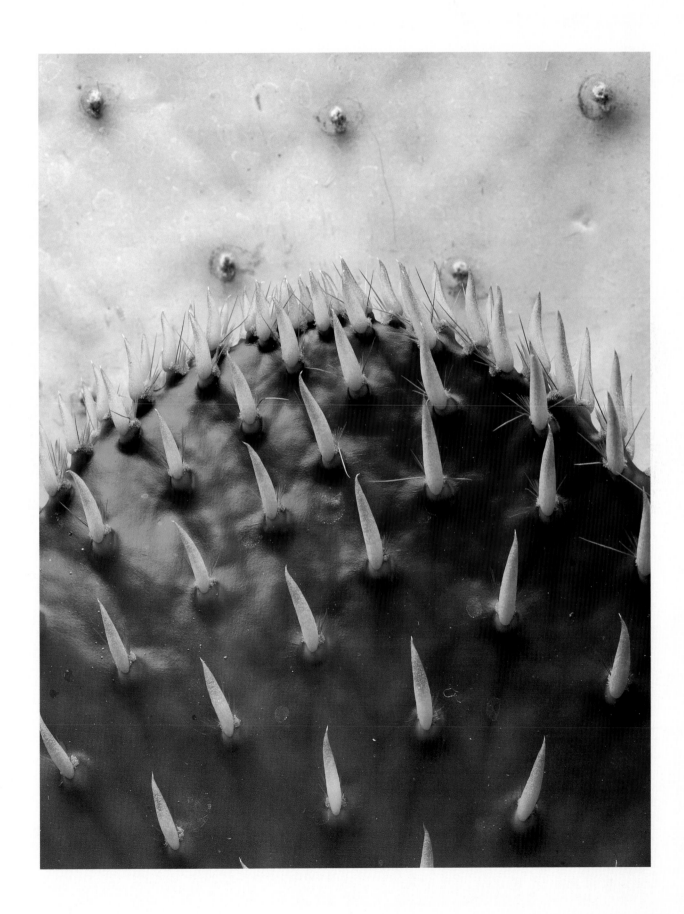

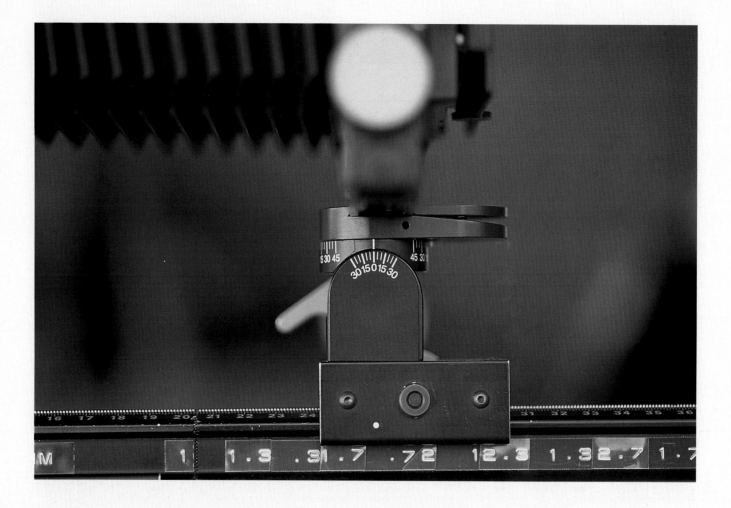

I decided that I would use this technique to create a bellows-factor scale, allowing me to quickly view the proper exposure correction necessary for future close-up situations. Beginning with the two lenses I use most for close-up photography, I set up several macro scenarios on my kitchen table and recorded variations in closeness and appropriate bellows factors. I printed out labels with scales giving me the increase in exposure for each increase in bellow extension. Red scales correspond to my 120mm APO Macro-Symmar HM lens, while the black scale gives the readings for my 180mm APO Symmar. With the bellows-factor scales mounted on my Arca-Swiss monorail and a white marker dot, I only have to glance at the proper increase in exposure, set my meter, and I'm ready to go!

For extra stability, I use a larger tripod for extreme close-ups. One of the features that makes monorail cameras a joy to use is the ability to tighten or loosen the composition by simply sliding the entire rail. I just loosen the monorail mounting block and slide the entire rail forward or pull back. This avoids the extremely tedious process of recomposing each time I move the tripod.

ABOVE: *The scale on the rail of my Arca-Swiss F-Field camera, with the rear standard marked with a white dot. As the bellows is extended farther to the right (from the lens at the left) the bellows factor increases. So, reading the red scale for my 120mm lens, I know that I must increase my exposure by about 1.8 stops.*

OPPOSITE, TOP: *Arca-Swiss F-Field camera set for a close-up.*

OPPOSITE, BOTTOM: *Arca-Swiss sliding closer to the subject while the tripod remains stationary.*

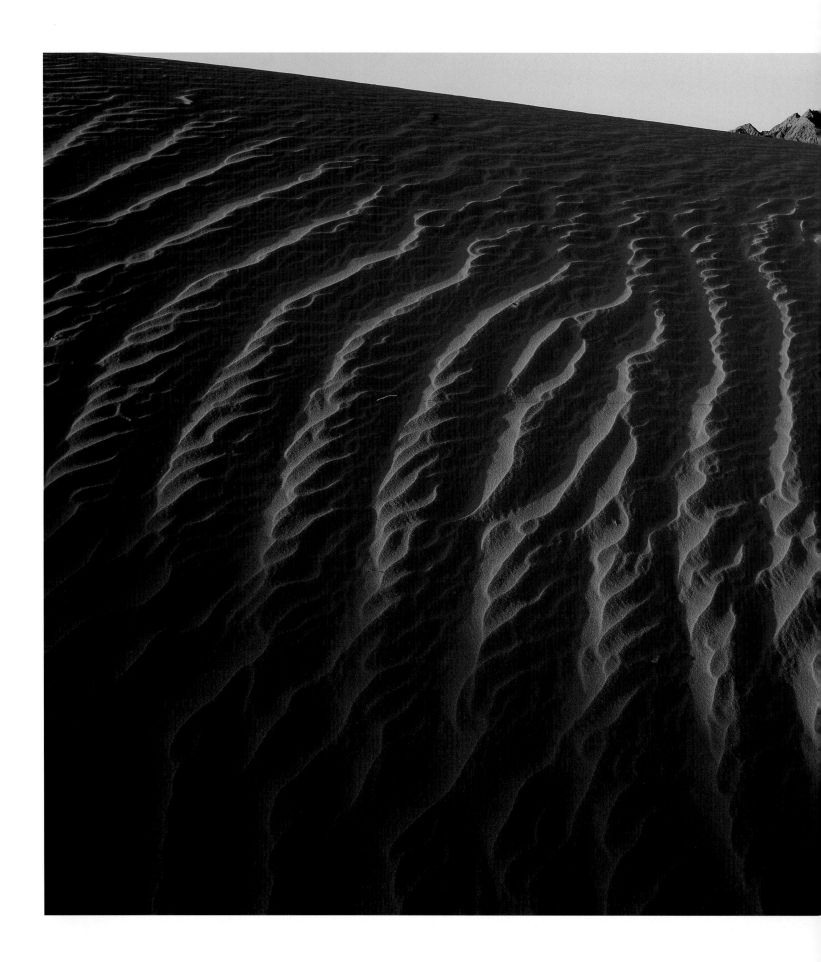

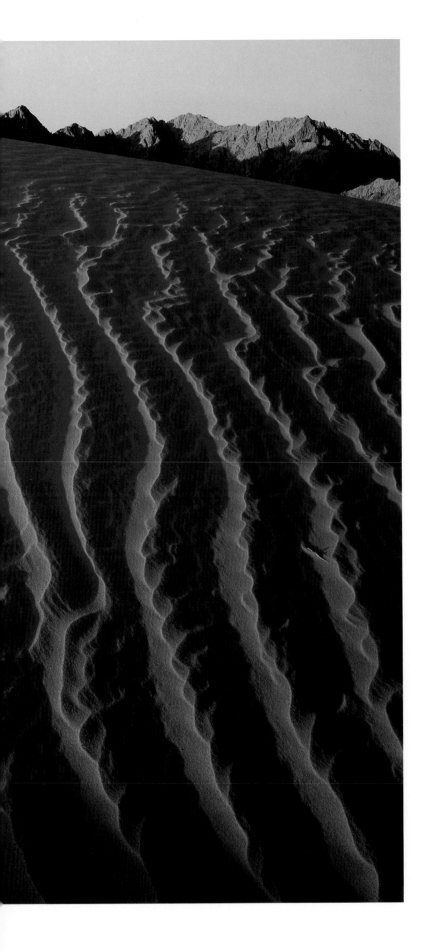

Exposure, Film, and Filters

Sand patterns at first light with the
Sierra del Rosario in the background.
Gran Desierto, Sonora, Mexico

Photography is all about light and film's sensitivity to it. Making sure that the correct amount of light reaches the film is determined by the light meter, which is set to accommodate a film's speed (ISO). Changing the color of light is accomplished by adding filters. They can also be used to even out exposure variances common with very wide-angle lenses or to equalize differences in the exposure within a scene.

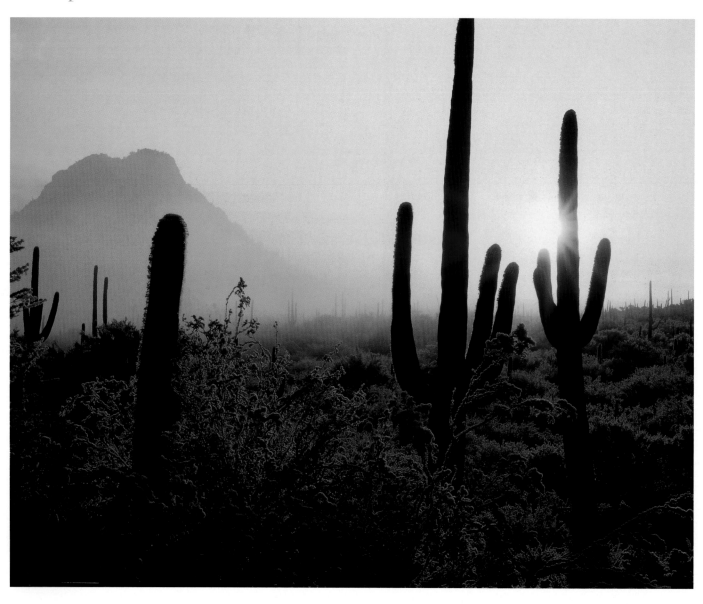

OPPOSITE: Saguaro cactus (*Carnegiea gigantea*) forest in fog and new-fallen snow at sunrise. Saguaro National Park, Arizona

Wista DX2 camera with Schneider Super-Symmar HM 120mm lens

This foggy dawn at Saguaro National Park is the tough kind of metering situation for which spot meters are made. By metering off the darker snow in the shadow areas, I was able to hold the detail at the lower section of the frame and silhouette the saguaro cacti.

THIS PAGE: *The Pentax digital spot meter's dial settings. Once, while making a photograph at a very low angle, kneeling in the middle of a shallow stream, I intently focused my camera with my Pentax meter dangling from my neck. To my horror, I looked down and noticed the meter was bobbing a few inches underwater! But I pulled it out, dried it off, and it's still working just fine.*

Determining Correct Exposure Determining the correct exposure in large-format photography can be a bit more involved than simply pointing a matrix-metered 35mm camera and letting the camera's microprocessor do the thinking—though sometimes, I do wish my spot meter could mimic my Nikon 90s! Several large-format photographer friends of mine do use their Nikons to establish the proper exposure. I do not. I've learned to trust my Pentax Digital spot meter over the years. I sometimes get fooled by the light's behavior, but by bracketing my exposures and processing a single sheet of film in questionable lighting situations, I feel confident about the results.

Whatever meter you choose, learn to be comfortable with it. Always check your meter's ISO setting, both before using it and when you finish photographing. I've averted disaster by simply rechecking my meter to make sure the film speed setting was correct. As I packed up, I noticed my meter's ISO dial had shifted from 40 to 64. I promptly isolated those improperly exposed sheets and marked them to be processed with a 1/2-stop push to compensate.

My Pentax digital spot meter is a very durable and accurate meter. Its 1-degree spot allows me to select an area within the scene and meter that isolated area. This is particularly useful when the subject is backlit. I can avoid the hotly lit areas within the composition and meter only the area I select as representative of mid-tone light values. I prefer the Pentax dial readout approach instead of numerical digital readouts employed by other meters. By setting the proper reading manually with a simple rotation of the dial, I'm able to see the differences as I consider exposure variables such as filter factors, bellows factors, and allowances for wide-angle lenses.

Myers Creek and coastal sea stacks at dawn's first light. Pistol River State Park, Oregon

Arca-Swiss F-Field camera with Schneider APO-Tele-Xenar HM 400mm lens

Here, I metered off the green cliffside plant life at the far right. I determined the exposure (4 seconds at f/45) and proceeded to bracket my exposures.

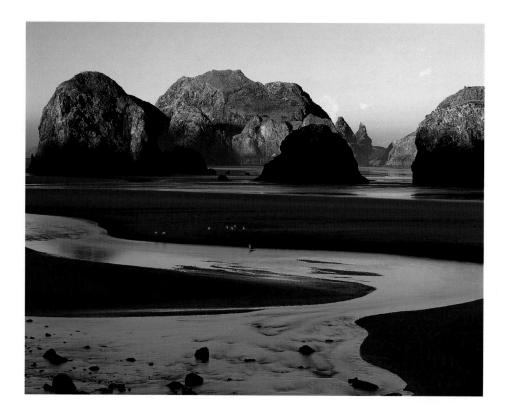

Exposure is a very subjective thing. Sometimes the "wrong" exposure is the "right" exposure. Many photographers prefer very rich, color-saturated images, while others insist on very "open" shadow areas with pastel colors. My technique is simple. I meter the areas in my chosen composition that my eye sees as a mid-tone. In other words, I read areas that would closely match an 18% gray card. In practice, that usually means reading off a medium green portion in my composition. While under the focusing cloth, I frequently stop down my lens to reduce the scene to shapes and light values. I carefully search out the ideal medium tonal range area. Emerging from my dark cloth, I place my meter's 1-degree spot on that very area. I'll sometimes check that against the hottest (brightest) and darkest areas, as well. If the light values are more than 5 stops apart, I'm apt not to photograph. I also carry a small gray card (18% gray) and meter off that when I'm in doubt.

Your comfort level in metering will increase through practice and experience. We all see mid-tone areas differently. Green areas in a scene are a relatively safe place to read; however, there are infinite shades of green. Place the meter's 1-degree circle on what you determine to be a medium green. Take your meter and practice in brightly lit scenes, soft light situations, and even shooting into the sun to establish your personal take on a "normal" exposure. Shoot film based on those readings, and process it to see if your eye and the film agree on a color equivalent to 18% gray. Slight compensations can be made by adjusting the meter's ISO to enable a "perfect" exposure. Many professionals rate Fuji Velvia film at 40 instead of the ISO 50 called for by the manufacturer. Others insist that it must be rated at 50. Practice and find out what works for you.

You can also read off white areas and open up your lens by from 1.6 to 2.3 stops, depending on how white you want your whites to be. For example, in shooting snow scenes, I meter the snow in soft, overcast light and open the lens 2 stops if I want the snow slightly bluish or 2.3 stops for pure white snow.

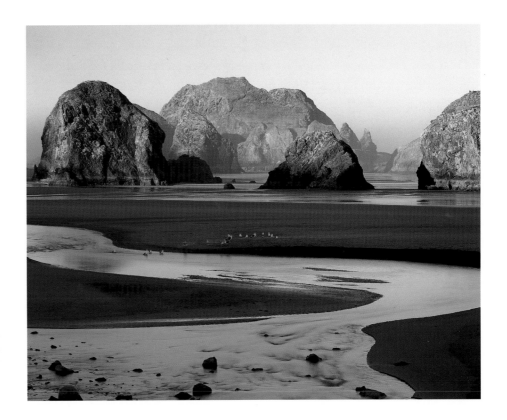

This is the same scene but overexposed 1/3 stop.

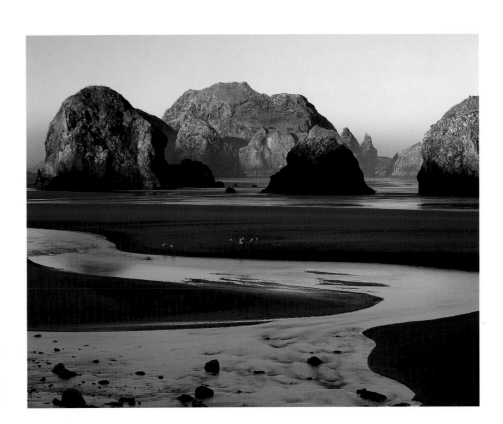

The final bracket is underexposed 1/3 stop.

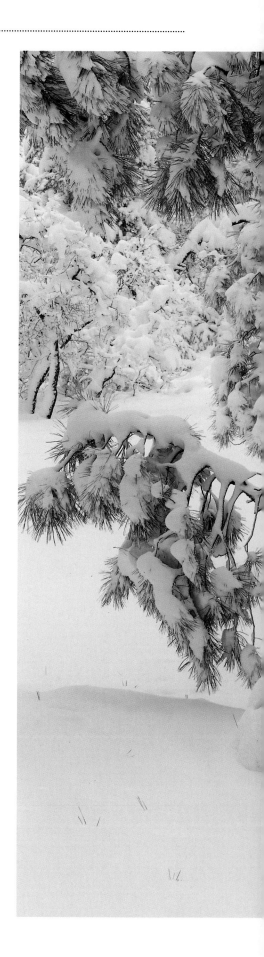

Shooting into the blazing Arizona sunsets has also become less of a chore. By metering off clouds about 30 degrees away from the sun's location, I usually find the 18% gray I'm looking for. Again, this is trial and error, but search for that cloud that looks like a mid-tone gray. When shooting into the sun, I shade the meter and again seek out what I believe is the mid-tone range. I've found that the new multicoated lenses are incredible—even when shooting directly into the sun—with flare greatly reduced or nonexistent.

When I'm working in foggy situations, with light reduced to gray tones, I again search out that mid-tone gray. By selecting a lighter area on which to meter, the overall look of the photograph will by darker and ominous. By choosing to meter off darker areas, the resulting image will appear very white with subtle shadows.

Snow-laden ponderosa pines (*Pinus ponderosa*). Grand Canyon National Park, Arizona

**Arca-Swiss F-Field camera
with Schneider APO-Symmar
180mm lens**

OPPOSITE: Dry lake bed with boulders. Death Valley National Park, California

Arca-Swiss F-Field camera with Schneider Super-Angulon XL 58mm lens

Using my Arca-Swiss camera and the 58mm Super-Angulon XL, I chose to photograph directly into the sun. The multicoating of this lens has prevented those nasty, hexagon lens flare aberrations from ruining the photo.

THIS PAGE: *This is my Arca-Swiss F-Field camera with wide-angle bellows and compendium lens shade. Whenever possible, I like to use a compendium lens shade (one that's basically another bellows that extends or contracts to keep light off the lens' front element) to minimize the contrast loss caused by sunlight striking the lens.*

No matter what exposure I finally choose, I always bracket my exposure. There are just too many variables that can affect the exposure of the finished image. Your shutter speed could be inaccurate, or you might be counting too slowly on long exposures. Your lab could have processing problems, or the film itself could be not quite the film speed advertised. All these potential problems are solved by simply exposing the bulk of your film as the meter dictates, and then bracketing exposures by increasing and decreasing the times to reflect a 1/3- to 1/2-stop over- and underexposure variance.

I like to change shutter speed and keep the lens opening the same. When the meter calls for an exposure of $f/45$ at 6 seconds, my underexposure would be at 4 seconds and the overexposure would be at 9 seconds. However, when faster shutter speeds are needed, you may have to open and close your lens to accomplish the desired 1/3-stop bracket. For instance, if the exposure is 1 second at $f/32$, I would expose one sheet at that exposure. To overexpose 1/3 stop, I would expose the next sheet at 1 second at $f/22.6$ (22 2/3). My underexposed sheet would also be exposed at 1 second but with the aperture set at $f/32.3$ (32 1/3).

For a very long time, I counted, One thousand . . . two thousand . . . and so on, for long exposures. My results sometimes amazed me with their inaccuracy. A photographer friend and exposure guru, Randy Prentice, suggested I use my watch's sweep hand. What a concept! Ever since, my exposures have been consistent.

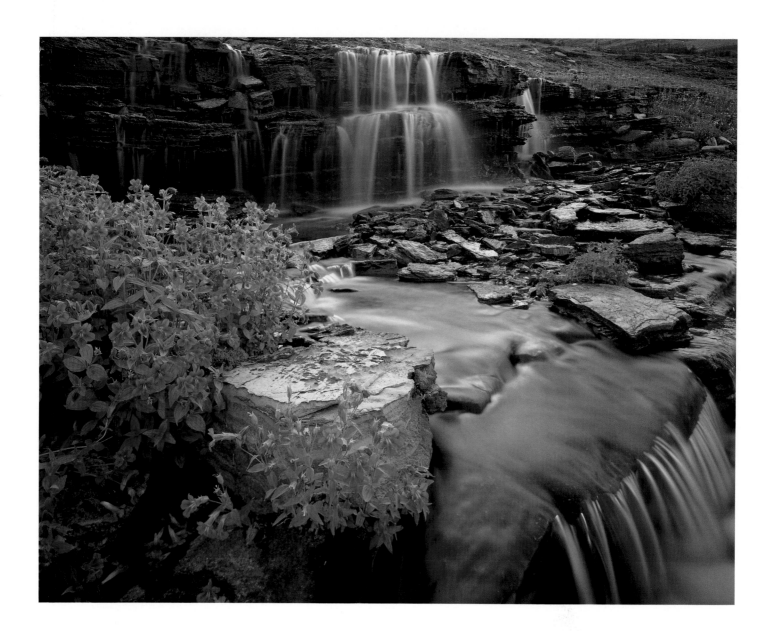

OPPOSITE: Lewis monkey flowers (*Mimulus lewisii*) lining the banks of Oberlin Falls. Glacier National Park, Montana

Arca-Swiss F-Field camera with Schneider Super-Angulon 75mm lens

The blurred moving water contrasting with the stationary monkey flowers makes this scene an interesting image. Generally speaking, my exposures are in the 1/4 sec.- to 20-second range. My lens opening is usually between f/32 and f/45, assuring greater depth of field. With a 4 x 5 camera, long exposure times mean that the decisive moment is when the wind stops blowing! Of course, moving water or grass can be an asset, too. Their velvety blurs of color may be just the dreamlike effect for which you're striving. (Note: Exposure here was f/32 at 6 seconds.)

THIS PAGE: Ladybugs covering the main stem of an Apache pine (*Pinus engelmannii*). South Fork, Cave Creek, Chiricahua Mountains, Arizona

Arca-Swiss F-Field camera with Schneider APO-Symmar 180mm lens

I photographed this pine bough covered with ladybugs with the lens wide open (f/5.6) to emphasize the subject and separate the foreground from the background. Exposing at a fast shutter speed with the lens wide open can simplify the composition by throwing the background into an out-of-focus blur while emphasizing the sharply focused subject.

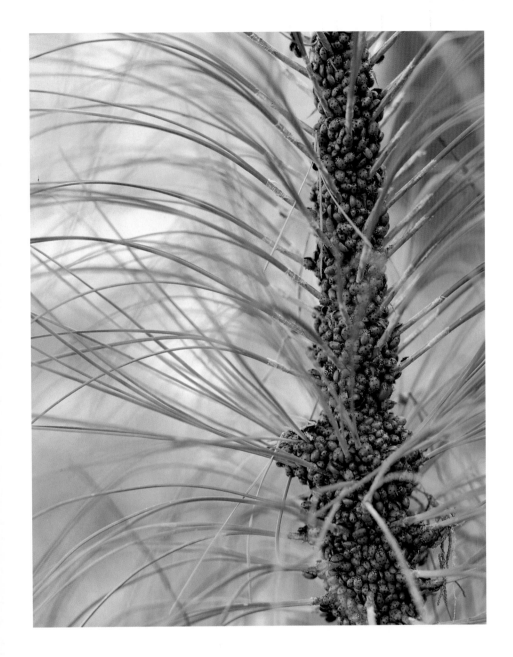

Film Fuji Velvia has enjoyed a long ride as the film of choice for most large-format color landscape photographers. For me, the reason is more than just the vibrant colors. It's the way the film handles long exposures with little reciprocity failure, plus its very fine grain. Kodak ISO 100 VS Ektachrome has similar characteristics. Since large-format photographers often making very long exposures with the lens stopped down to $f/45$ or smaller, reciprocity failure is something they must deal with and consider.

Reciprocity failure means that your film begins to "see" colors differently as the length of exposure increases. It also means that during very long exposures, you must increase the exposure time. So, when making a 9-second exposure, you would need either a 5 magenta or a Tiffen 812 filter to correct the color accuracy, and you would compensate for the filter by adding 3 more seconds to the exposure. In addition, due to the length of the exposure, you'd now need to add 5 more seconds, making the overall exposure 17 seconds!

John Shaw's Nature Photography Field Guide (Amphoto Books, 2000) lists the following reciprocity failure guidelines. Though these are factory-suggested exposure compensation factors, I tend to be more conservative when increasing exposure. Try bracketing between the manufacturer's recommended factors and half that increase. So, when Fuji calls for an increase of 1 stop in exposure, shoot some with a 1/2-stop increase, and see which works for you.

Exposure Compensation for Reciprocity Failure

In these recommendations for exposure compensations for different films, the numbers shown as "+" values indicate the number of stops of light to be added. Whereas this chart is concerned with the typical 35mm camera's relatively short exposure times, large-format photographers must recognize that long exposures are the norm rather than the exception. This is still a good starting point for determining compensations.

FILM	4 SECONDS	8 SECONDS	16 SECONDS	30 SECONDS
Fuji Velvia	+1/3	+1/2	+2/3	+1
Fuji Provia III	none	none	none	none
Fuji Astia	none	none	none	none
Kodak E100SW	none	none	+1/3	+1/3

Note: Chart information is available from both the Fuji Film USA website at www.fujifilm.com and the Eastman Kodak website at www.kodak.com.

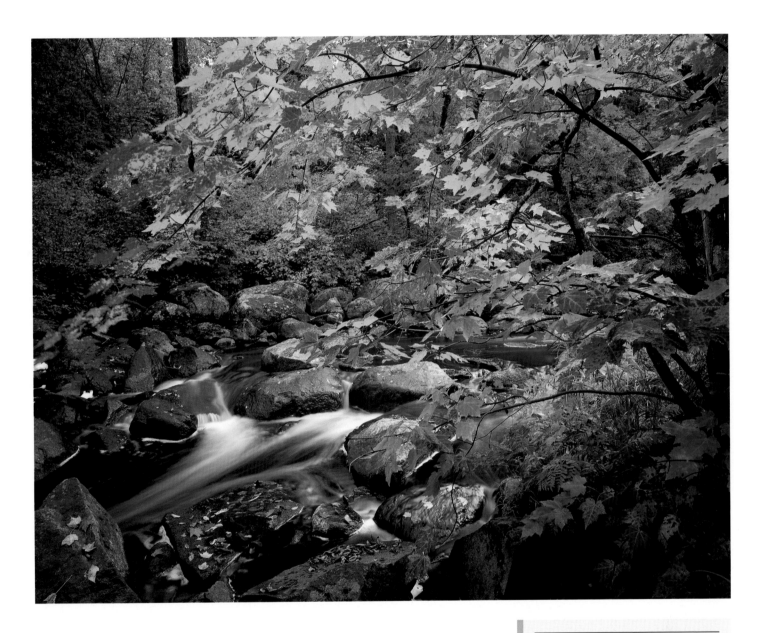

Red maple *(Acer rubrum)* on bank of Little Indian Sioux River. Boundary Waters Canoe Area, Superior National Forest, Minnesota

Arca-Swiss F-Field camera with Schneider Super-Angulon 75mm lens

Fall colors come to life recorded on Fuji Velvia film.

Velvia is at its best in soft light when its saturation and contrast bring the vibrant colors your eye sees to life. That same contrast can destroy an image in very harsh light, however. In those cases, I use either Kodak's VS or Fuji Provia III. Both have better shadow detail and less contrast than Velvia and are ISO 100 films. For more neutral colors (for subjects needing to be pure white), I like the ISO 100 Fuji Astia.

Fuji's Quickload holder lets me leave the weight and bulk of standard two-sheet film holders behind. Another lightweight option is my Horseman 6 x 12 panoramic 120 roll-film back. This is an option with cameras such as my Arca-Swiss that feature a Graflok back that accommodates the Horseman and other similar backs.

Quick, safe access to film is often critical to success. Justin Gnass of Chico, California, has come up with ways to pack both standard film holders and Quickload holders and film. He has devised nylon pockets, called the Rapid Load File and the Film Holder File, that hang from the tripod and hold film at ready access. They're really great when you're in a situation that prohibits access to your pack. Using his device, I can photograph while standing knee-deep in water, amid shifting snow, or in blowing sand. My film is kept high and safe.

THIS PAGE: *My Wista DX2 camera on the Gitzo Mountaineer tripod with the Gnass Rapid Load File pocket (with film) and Quickload holder hanging from the tripod.*

OPPOSITE, LEFT: *The Gnass Film Holder File with eight standard 4 x 5 film holders in the pockets*

OPPOSITE, RIGHT: *Fuji Velvia Quickload film, Fuji Provia roll film, the Fuji Quickload holder, the standard Fidelity holder, and the Horseman 6 x 12 roll-film back.*

Choosing a film processing lab is more important than most photographers think. A good pro lab, such as Photo Craft in Boulder, Colorado, will process my film (shipped from the field), give me a rundown on exposures and potential problems, and FedEx the processed film to my office (often before I get there). Besides great service, the quality is always consistent. Consistency is what you're after. No surprises!

Going Digital

Recently, I had a chance to photograph without any film. I used a Phase One scanning digital camera back. Together with digital photography guru Russell Sparkman from Nagoya, Japan, I set about photographing the landscape of Arizona and Utah in a whirlwind two-week shoot. Whirlwind was right! The two-week period we selected proved to be one of the windiest on record. We built tents of white nylon to break the wind, but the wind blew them over.

The first apparent problem came from the excess heat in Arizona in May. Scan lines became increasingly apparent while working in the heat. Wind was the other major problem. The camera itself must be extremely stable during the long (12- to 18-minute) exposures. To further complicate things, the subject must also be stationary, and the light consistent and steady. Unfortunately, we were forced to work in conditions of high winds, blowing subjects, and varying light!

Still, we managed to pull out several successful images with 144-megabyte files. I do believe future digital cameras will be lighter and feature faster capture times. Right now, however, I still believe that a single sheet of 4 x 5 film, with its ability to capture 1.5 gigabytes of information, is tough to beat—and you don't need two people carrying 60 pounds of equipment each!

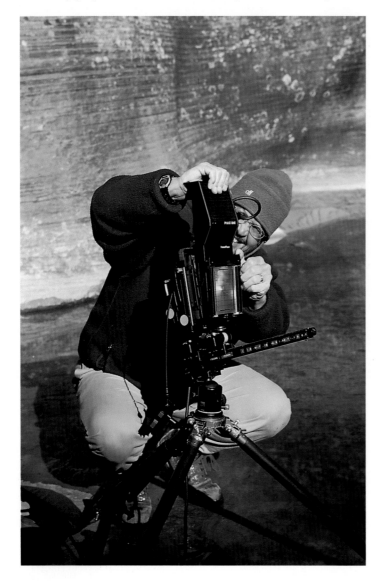

I try to carefully slide the Phase One digital back into my Arca-Swiss F-Field camera's rear standard. This scanning back was then linked by cable to Russ' Apple G3 PowerBook. While we knew the Phase One was designed for serious studio work, we wanted to push its limits in the field. (Photo © Russell Sparkman)

OPPOSITE: *Russell Sparkman with his Apple G3 laptop cabled to the camera and Phase One digital scanning back in a Colorado Plateau canyon.*

Filters Whenever I speak to a group of photographers, the one question that always comes up is, "Do you use filters?" Of course I use filters! The human eye and film do not see colors the same way. The long exposures often required for large-format color photography cause shifts in color balance (see reciprocity failure information on page 106). Filters enable film to reproduce color as the human eye sees it, and they also correct color imbalance caused by an exposure that's several seconds long. Note, however, that overfiltering can also distort the color balance.

A good basic filter kit should include the following: a B+W 81B warming filter, both B+W polarizing and warming polarizing filters, and a Tiffen 812 filter (a slight warming filter with a magenta cast). A B+W 5CCM filter is recommended by Fuji for long exposures, when color shifts occur (CC stands for color correction and M for magenta). B+W has a new 81-two filter that works well in situations when extra warming is required, such as at high altitudes or in shadowy areas in canyon bottoms. When I view images fresh from the lab on the light table, I sometimes lay various filters over them to see which one best matches my memory of the scene and to help decide proper filtration for future images.

Standardizing filter sizes is a great way to lighten your load. All my lenses have 77mm adapters, allowing me to use a single set of 77mm filters. Wide-angle lenses, with their large acceptance angle, need a step-up ring, going from 67mm to 77mm. Besides enabling the use of the large 77mm filters, the step-up rings provide extra space between the surface of the lens' bulbous front element and the filter. Without the step-up ring in place, abrasion of the lens' front element can occur due to some filters seating too deeply against the front element when screwed tightly in place.

In my experience, some manufacturers' 210mm, 75mm, and 90mm lenses all have front elements that are quite exposed. If you think this could be a problem, here's a simple test. With the filter off, place a small 1-cm square of tissue at the centermost bulbous point of your lens. Placing the lens on a table, front element up, begin to attach the filter. In this way, you can see immediately if there is contact between the filter and the front element—without damaging the lens—by seeing if the tissue is flattened tightly.

My 180mm, 270mm, and 400mm lenses all have 58mm to 77mm step-up rings. The APO-Tele-Xenar 400mm requires an 82mm on the front element; however, the rear element is threaded to accept my 58mm to 77mm adapter as well.

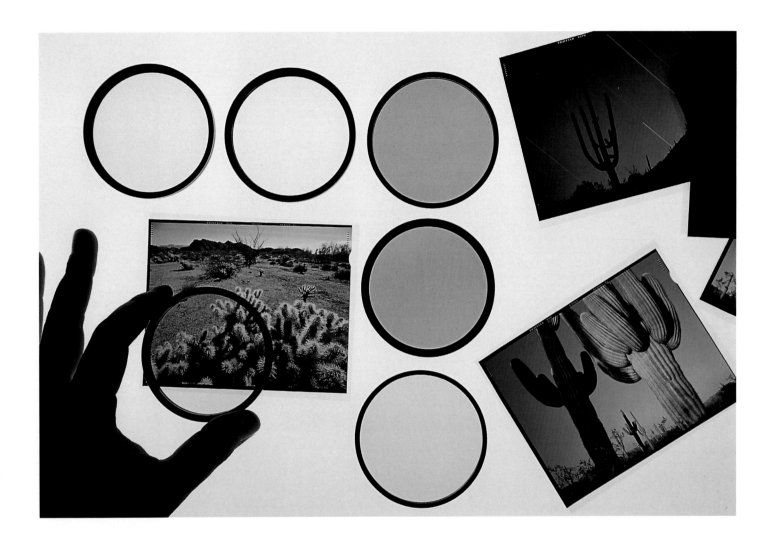

My basic filter kit on my color-balanced light table. I'm holding the B+W 81-two filter, with the Tiffen 812, B+W 05 Magenta, B+W Polarizer, Warming Polarizer, and 81B filters surrounding the image. This is a great way to visualize each filter's effect and to determine your personal color preferences. It's very important to do this on a color-balanced light table (one that accurately represents daylight).

Mounting filters on the rear element of the lens works very well for most filters, and smaller-sized filters can be employed for this. However, not all lenses are threaded to accept filters on the rear element. They may require improvising either by a clip-on adapter or even tapping the filter in place. The exception to this is the polarizing filter; it needs to be mounted at the front of the lens for maximum effect. I place filters on the rear element when the front element is either too large (as with my 400mm) or too wide (as with my 58mm Super-Angulon XL with a center filter in place).

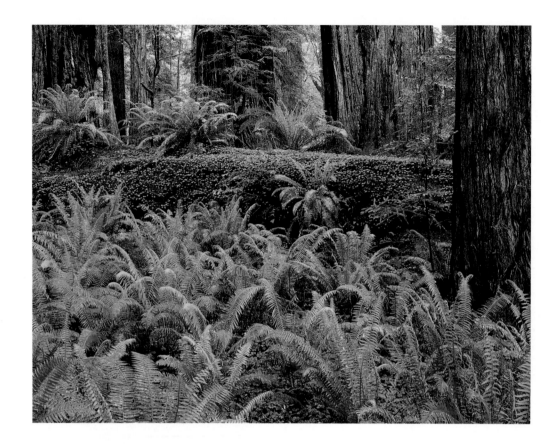

Redwoods *(Sequoia sempervirens)* with carpet of Pacific Coast sword ferns *(Polystichum munitum)*. Prairie Creek Redwoods State Park, California

Arca-Swiss F-Field camera with Schneider APO-Symmar 180mm lens

The photograph above, taken on Fuji Velvia and using an 81B filter, is okay. However, the same scene becomes emerald green when shot using a warming polarizing filter.

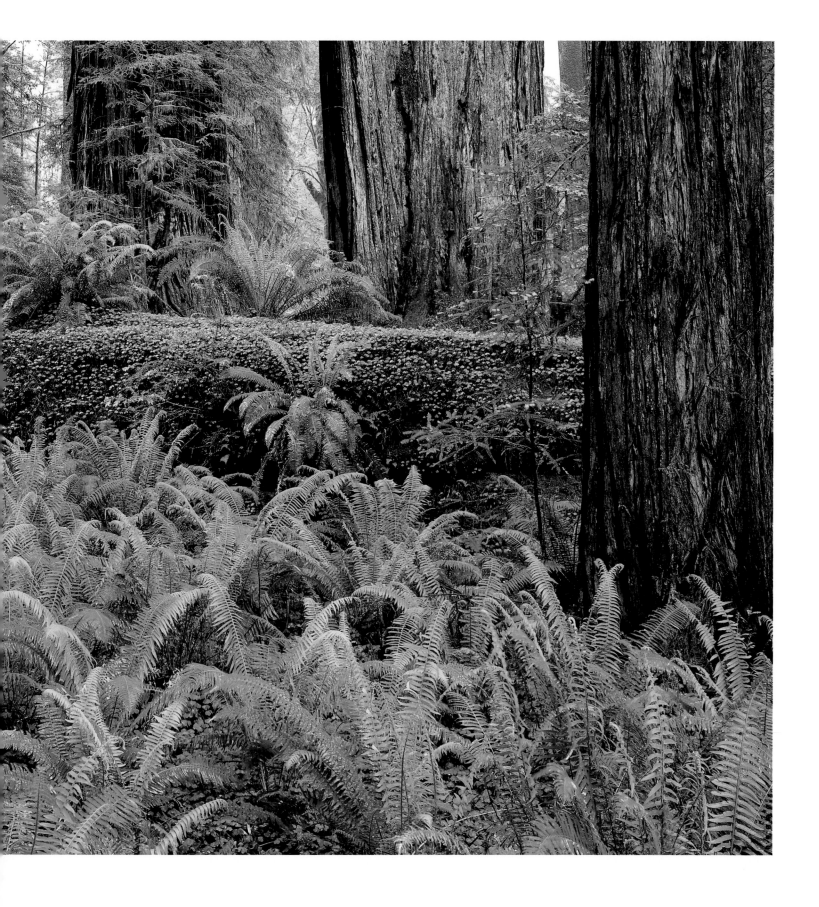

When I began photographing the landscape of the Southwest, I consistently overfiltered. I mistakenly used a blaze of warm color to gain impact. Overfiltering overpowers the subtle nuances and pastel tones and replaces them with red. Nowadays, I'm very conservative in my use of filters. By cutting back on my filtration or only using a small amount of color correction, I now try to let the cool blue cast of the shadows set off, or complement, areas in which the warm sunlight tones occur.

Likewise, the polarizing filter is also overused. Yes, when clouds are an integral component of an image, I use it. I also use it when I worry that the blue sky will fade to a chalky robin's-egg blue or white. And, using the warming polarizing filter can make green vegetation look very lush. As a rule of thumb, I open up my lens 1.7 stops with my polarizing filters, but I must caution that some filters need as much as a 2.3-stop increase.

To determine the increase in exposure, use the Pentax spot meter and read the light through the filter. Simply read an area of consistent light value. While taking the reading, add the filter in its maximum polarizing position and note the variance in exposure readings. The 5CCM, 812, and 81B filters call for increasing the exposure by 1/3 stop. The B+W 81-two requires an increase of 1/2 stop.

Warming filters let photographers work in shadowed areas with soft light and counter the bluish cast associated with this type of light. There's also a blue/cyan gain during long exposures. So, the 812 filter is a good choice to combat both UV problems and reciprocity failure. When I'm photographing green subjects, I prefer the warming polarizing filter or the 81B. With low light, I'm apt to use the 81B.

Wide-angle lenses spread the image over such a large area that the scenes often display a fall-off in exposure from the center to the edge of the image. You can use this to your advantage by placing brighter objects near the edges, where light fall-off occurs. If, however, even illumination is your goal, you'll have to use a graduated neutral-density center filter. This is a very expensive optical glass filter, which is slightly darker in the center and lighter at the edges. The Schneider Center filter on my 58mm lens necessitates a 1- to 1.3-stop exposure increase to achieve an edge-to-edge balanced exposure. That same filter can also be used on both the 110mm and 80mm Super-Symmar XL lenses.

Arizona lupine (*Lupinus arizonicus*) amid smoke trees (*Psorothamnus spinosus*) in the arroyos of the Sheep Hole Mountains. East Mojave Desert, Bureau of Land Management, California

Arca-Swiss F-Field camera with Schneider Super-Symmar XL 110mm lens

The last light of day bathed this flowering lupine with warm light, and I could photograph it without a warming filter. The shadow areas then retained their cool bluish cast.

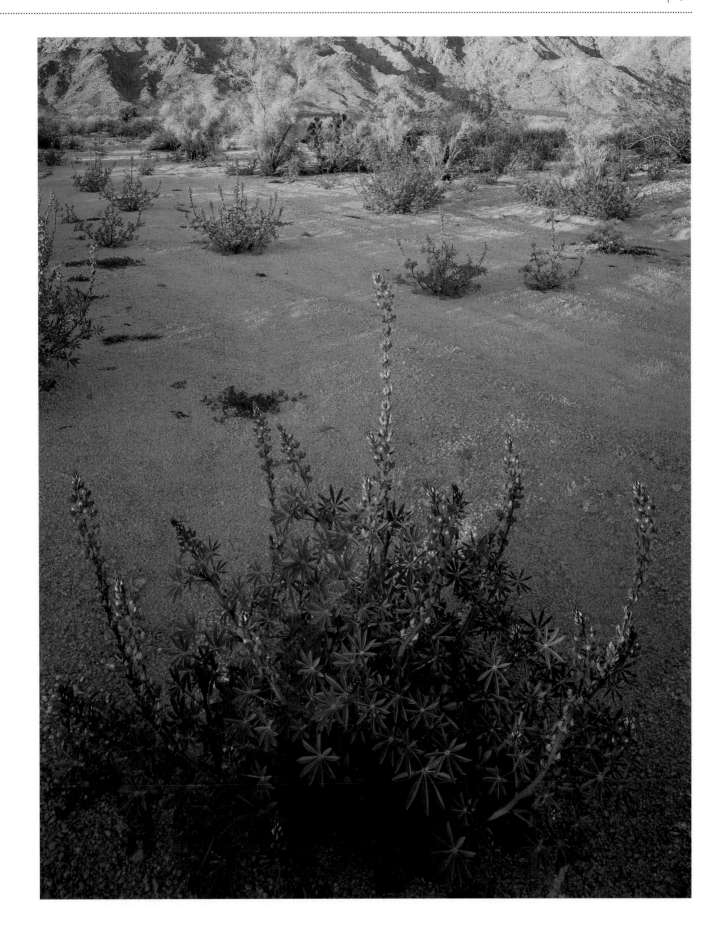

Cracked lake bed at dawn. Wilcox
Playa, Arizona

**Arca-Swiss F-Field camera
with Schneider Super-Angulon XL
58mm lens**

*Taken with a 58mm Super-Angulon XL,
there's noticeable edge fall-off at all four corners
of the image.*

In all cases, my feeling is that if I'm spending $1000 or more for premium optics, my choice for filters should also be of that same high optical quality. Therefore, I shy away from plastic or gel filters. I like B+W filters because they're made from optical glass. Durability in the face of frequently unfriendly elements makes screw-in glass filters the only choice for field work.

I urge photographers not to let their use of gimmick filters get in the way of integrity. We've all seen images with sunset light that were made at midday with warm-tone graduated filters. Work that's glitzy and unrealistic loses credibility. I've found that the images that truly endure are, above all else, honest.

ABOVE: *By fitting a center filter to the lens, I evened out the exposure, even into the image corners.*

LEFT: *Schneider 58mm Super-Angulon XL lens with center filter in place. Note the shading on the filter, darkening the center, while remaining clear at the edges. (Notes to myself regarding both movement capabilities and exposure correction are taped to the lens board.)*

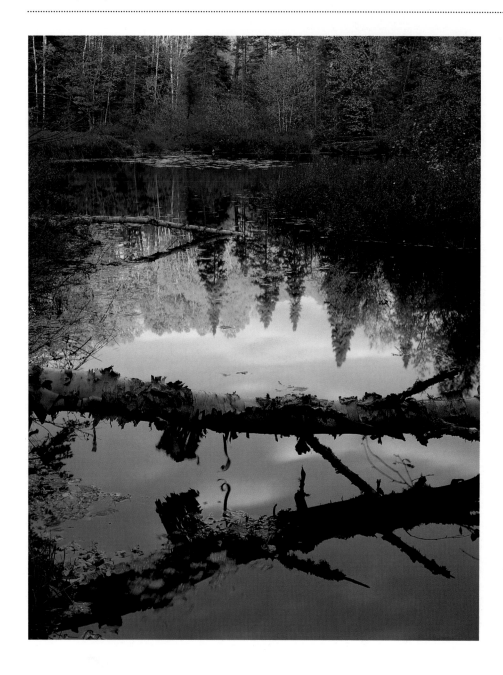

THIS PAGE AND OPPOSITE: Felled paper birch tree *(Betula papyrifera)*. Boundary Waters Canoe Area, Superior National Forest, Minnesota

Arca-Swiss F-Field camera with Schneider APO-Symmar 180mm lens

In the version at left, I wanted the blue sky reflections to be vivid, so I photographed the scene without any filter. By simply adding a Tiffen 812 warming filter opposite, I brought out more of the fall foliage color.

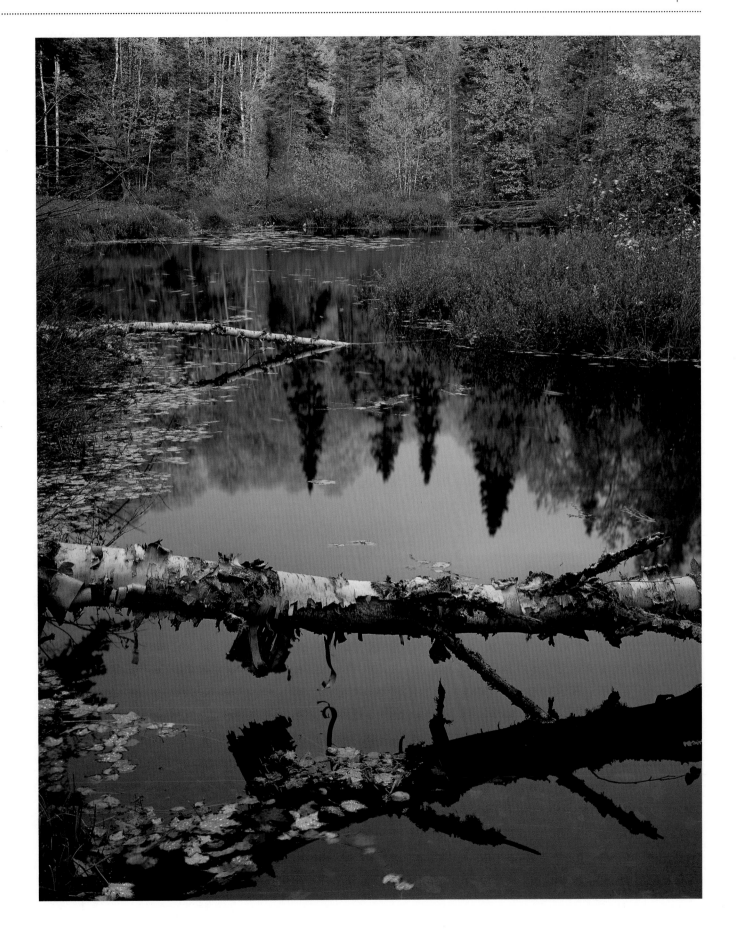

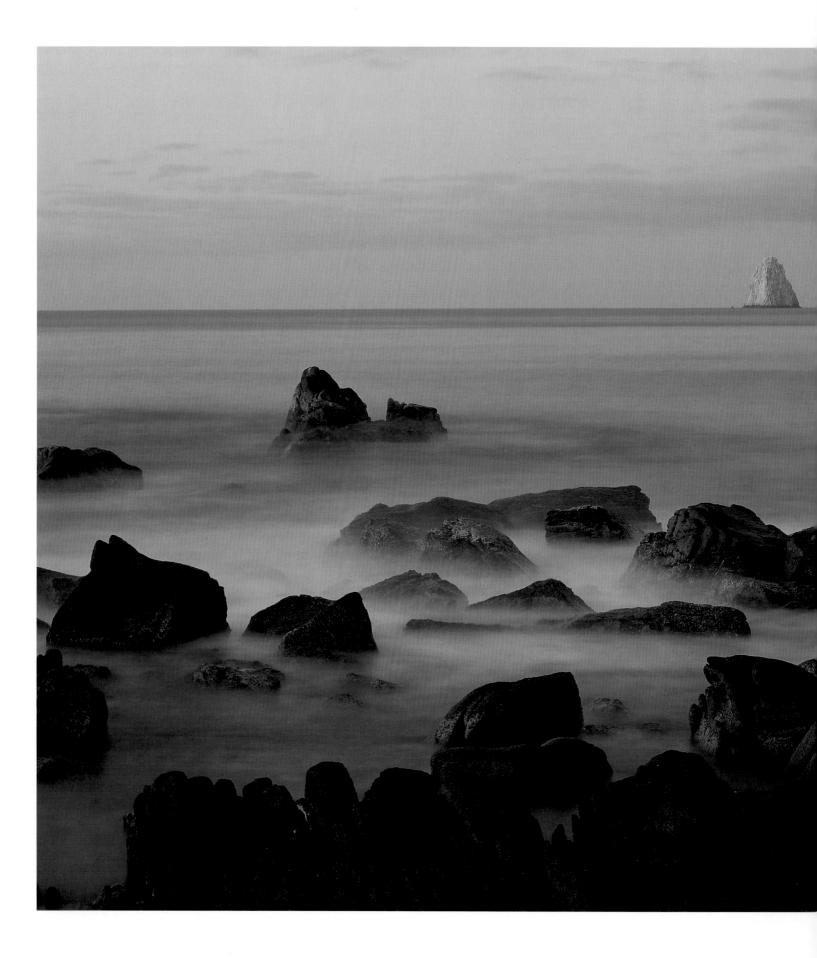

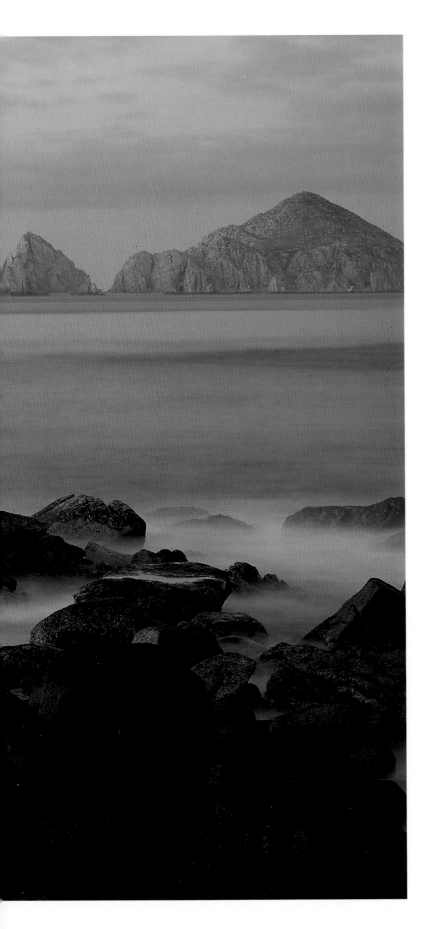

Gear and Weather

Baja in predawn light. Cabo San Lucas,
Baja Sur, Mexico

It's never easy being a beast of burden. But when I must carry a heavy load of camera equipment, I want to do it with a degree of comfort, and I want my equipment well protected. Being a backpacker for over thirty years, I've learned that a pack that lets me distribute weight between my shoulders and my hips is essential. So, the first thing I look for is a pack with a very substantial, comfortable, and adjustable suspension system. I use three different pack arrangements for carrying my equipment.

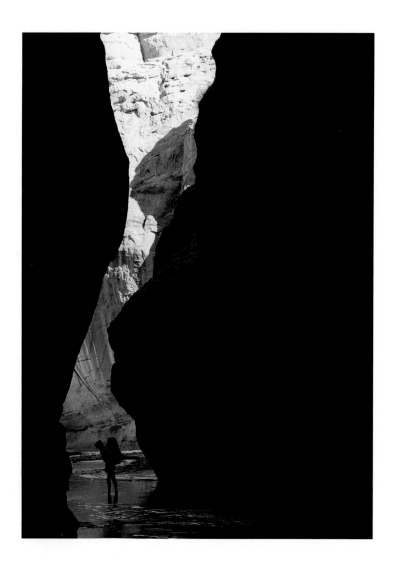

Writer Charles Bowden deep into Paria Canyon on a winter backpacking trip that began our book Stone Canyons of the Colorado Plateau *(Harry N. Abrams, 1996). Taken with my Wista DX2 camera and Schneider APO-Symmar 180mm lens.*

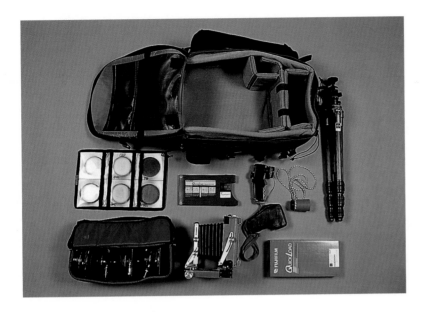

Lightweight pack setup with Lowepro Trekker AW pack and Wista DX2 camera.

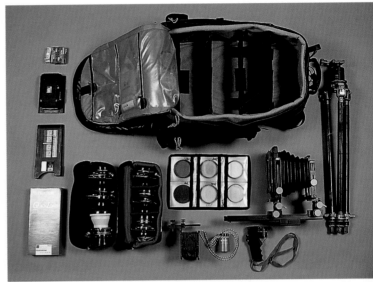

Standard pack setup with Lowepro Super-Trekker AW and Arca-Swiss F-Field camera.

For traveling light and fast, I use the Lowepro Trekker AW to carry my Wista DX2 camera and four lenses (75mm, 120mm, 180mm, and 270mm), Pentax digital spot meter, filters, Fuji Quickload holder, forty Quickload sheets of film, Schneider 4X loupe, and Gitzo Mountaineer tripod. (I like to use the cherry-wood Wista DX2 camera when backpacking or hiking to distant subjects; in those situations, the Wista's 3-pound weight becomes an advantage. The trade-off is that it's not as precise or stable as my Arca-Swiss camera.) Total weight: 25 pounds.

The Lowepro Super-Trekker AW is my standard pack when I use my Arca-Swiss camera. It can accommodate the basic Arca-Swiss F-Field camera, extra bag bellows, six lenses and assorted filters, lens shade, Pentax digital spot meter, Schneider 4X loupe, forty sheets of Quickload film, Quickload holder, and Gitzo 241 tripod. In addition, I carry water purification tablets, toilet paper, a pick-style comb (for removing cholla cactus buds), extra meter batteries, a flashlight, felt marker pen, and gray card. Total weight: 42 pounds.

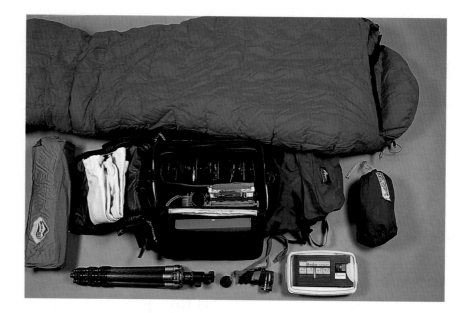

Gregory Rainier internal-frame backpack with my lightest camera bag nestled inside.

Organizing your equipment pays off. Here, I've packed my lenses by type: The blue Gnass Multiple Lens Case (manufactured by Justin Gnass of Chico, California) has my three wide-angle lenses (58mm, 75mm, and 110mm), while the red case holds my 180mm, 270mm, and 400mm lenses.

When I'm backpacking and spending one or more nights in the field, I use my huge Gregory Rainier internal-frame backpack. It has a zippered-panel entry that I use to get to my Zone VI box-shaped camera bag, which I pack inside it—so I can access my Wista, four lenses, and film without opening the entire backpack. I can photograph as I hike, with very little inconvenience. Of course, backpacking means I'm also carrying food, shelter, sleeping bag, foam sleeping pad, stove, and water. I take only what's absolutely necessary—even cutting the amount of food. For shelter, I pass on carrying a heavy tent and instead opt for a lightweight Western Mountaineering Goretex bivi sack. When spending just one night in the field, I leave my stove at home and just take a large bag of granola and water. The rule of thumb is: You won't feel like photographing anything if you're too tired to stand or think straight. So, pack light and enjoy the trip.

"Must Stuff"

This is an important support kit (to keep in your car) that augments, repairs, and adapts—and makes otherwise "impossible" photographs possible.

Canned air. I keep a can to blow dust particles off lenses, focusing screens, holders, and filters. Many times, this has prevented disaster by providing thorough cleaning—without abrasion—of filters dropped in sand.

Comb. In the desert where I live there are plants—cholla cacti—that seek out photographers and try to hurt them. The comb allows me to remove the thorny cactus balls without further harm.

Extras. Spare batteries, spare light meter, and spare Quickload film holder.

Gaffer's tape. A strong black tape used on movie sets. I keep spare pieces of this taped to my lens covers, tripod legs, and plastic Quickload holder box. I then have it handy to tape filters to rear elements of lenses, keep delicate subjects from moving, and even repair light leaks in my bellows.

Headlamp. I use this for early-morning setups in the dark. It lets me focus the light while keeping my hands free to work.

Indelible marking pens. For writing special instructions to the lab, and recording locations and time of day.

Jeweler's screwdrivers. A set of these can tighten loose screws just about anywhere. I've used them to reattach cable-release openings, tighten loose focusing screens, and fix a dropped Quickload holder.

Leatherman Micra tool. The combination of a small knife, tiny screwdriver, scissors, and tweezers makes this a handy repair tool.

Lens cleaning solution. A must, though sometimes I use my breath.

Lens cloth. Don't leave home without it! A light touch will remove dust particles. I use Pentax's cloth.

Lens wrench. Both Toyo and Rodenstock make versions of this stamped-metal "key" that fits 0, 1, and 3 shutters. You just never know when you'll need to tighten or remount a lens.

Nylon cord. There's no telling all the uses for this stuff! I've lowered packs, belayed myself, tied back foliage, attached rain protection over cameras, and secured tripods in the wind. Twenty feet is a good length to have.

Toilet paper. Besides the obvious use, it can also clean camera equipment.

Water treatment pills. I've gotten in the habit of keeping these iodine tablets in my pack, though I've used them only once when water was scarce. One time in the desert is all you need!

Weather The best light is often associated with bad weather. Or maybe I should say, the best images result from bad weather. So don't fight it, go with it. With a few preparations, you'll learn to love "bad" weather.

Rain

Almost every motel in America has the ideal item for protecting your camera in the rain: the shower cap. Simply slip the elastic cap over your camera until you're ready for the elements. For larger cameras, try the vinyl zippered storage containers that often serve as packaging for new linens and blankets.

In a steady drizzle, an inexpensive clamp-on umbrella works just fine. However, it becomes an unwieldy sail in the slightest breeze. The neat thing about the clamp umbrella, though, is that you can position it exactly where you need it most by bending the flexible arm. I generally set the camera up under the umbrella and then, when I've mounted the lens, cover everything with the shower cap. If I need to grab the entire outfit to change locations, I'm ready to go.

LEFT: *Arca-Swiss F-Field camera under a vinyl storage bag.*

BELOW: *My Arca-Swiss camera and Schneider Super-Symmar XL 110mm lens remain dry and ready to work.*

TOP: Moss-covered red adler *(Alnus rubra)* leaning across Mill Creek. Jedediah Smith Redwoods State Park, California

Arca-Swiss F-Field camera with Schneider APO-Symmar 180mm lens

An image taken while the camera and lens were under an umbrella.

BOTTOM: Red maple *(Acer rubrum)* against big-toothed aspen *(Populus grandidentata)*, white birch *(Betula papyrifera)*, and wood ferns *(Dryopteris sp.)*. Acadia National Park, Maine

Arca-Swiss F-Field camera with APO-Symmar 180mm lens

The fall colors jump to life when photographed during steady drizzle.

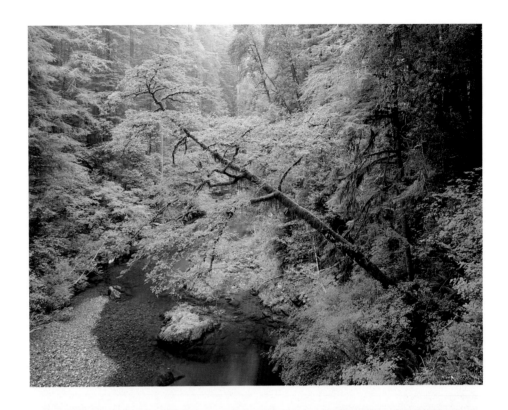

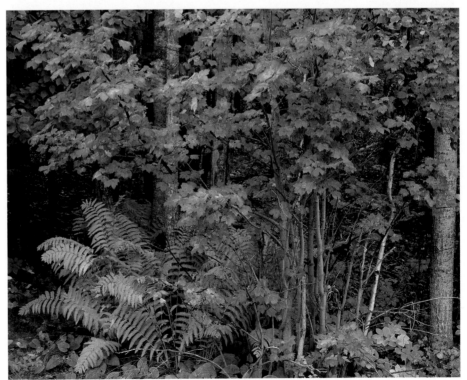

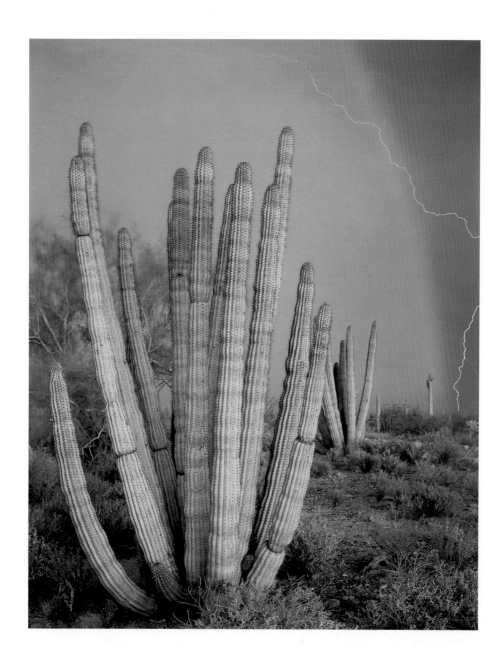

Organ pipe cactus (*Stenocereus thurberi*) at sunset with storm approaching. Organ Pipe National Monument, Arizona

Arca-Swiss F-Field camera with Schneider Super-Symmar HM 120mm lens

A storm's fury with high winds, lightning, and even a rainbow makes a great photo opportunity. Though after only a few exposures, I fled the very real threat of lightning. Rainbows are the sort of thing you must be ready to pursue. When I see a veil of rain beneath a cloud, I position myself so that when the sun sets, I'm between the cloud and the sun. The idea is to anticipate the sun striking the rain and guess where it might produce a rainbow.

Narrowleaf cottonwoods *(Populus angus-tifolia)* covered with ice. Grand Teton National Park, Wyoming

Arca-Swiss F-Field camera with Schneider Super-Symmar XL 110mm lens

As I composed this image on the ground glass in temperatures below zero, I was careful not to exhale under the focusing cloth. If I had, the image would have quickly disappeared under a layer of frost.

BOTTOM: *Here, my son Peter uses a flex fill to both soften the light and minimize the effect of a slight breeze.*

Wind

An umbrella also serves as a portable windbreaker, keeping the camera stable in windy conditions. Collapsible reflectors known as flexfills can also make terrific windshields, keeping the camera steady and breaking the wind that could disturb foreground foliage. An extra tripod with some hardware-store clamps can brace the flexfill when you don't have an extra set of hands to support it.

Low Temperatures and Snow

Cold weather presents a whole new set of problems. Besides the obvious effects on battery life, cold weather makes viewing the ground glass problematic: Each exhaled breath under the focusing cloth produces an instant coating of ice on the glass. For even the most seasoned pro, this is a real problem. You can try a reflex viewing device, which Arca-Swiss and other companies offer as an accessory, that eliminates the problem by keeping the ground glass covered and away from exhaled air. I've simply learned to hold my breath. I've even had friends suggest using a snorkel that would take the exhaled hot air outside the focusing cloth.

A far more insidious problem occurs when my lens slowly fogs up *inside* the camera. This occurs especially in the predawn hours, when I am setting up the camera during the coldest part of the day. As the sun warms the bellows, the icy cold metal and glass of the lens draw condensation. It occurs slowly, and you probably won't notice there's a problem until you finish shooting. The resulting images are marked by low contrast, as though taken through a dense layer of fog. To prevent this, when the sunlight begins to feel warm against my face, I detach the front of my bellows and check the lens; I repeat this after two or three exposures to both make sure the lens is fog free and release the humidity.

An additional concern comes with my Wista DX2 camera, which arrived with a thick layer of wax lubricant in the focusing rail. In very cold weather, this turns to molasses, hampering the smooth focusing operation. I've learned to carefully clean and remove the wax with alcohol and replace it with a fine silicone spray lubricant.

Fog

Fog is, perhaps, my favorite weather condition. The layers of wispy blue hues screen out extraneous details and help produce a clean, simple image. It brings drama to situations. A mistake that many photographers make when working in fog is exposing their film with very long exposure times. The longer the exposure, the more the fog moves through the frame allowing the image to gain clarity on the film. With short exposures, you can maximize the foggy look. In heavy fog, you must take constant care that the lens isn't covered by mist. I generally keep a Pentax micro-pore cloth handy for cleaning the lens.

Bridalveil Falls under a shroud of fog.
Yosemite National Park, California

Arca-Swiss F-Field camera with
Schneider G-Claron 270mm lens

Layers of fog give a sense of drama to Yosemite Valley. Though I used a slight warming filter, the inherent blue quality of the light is apparent.

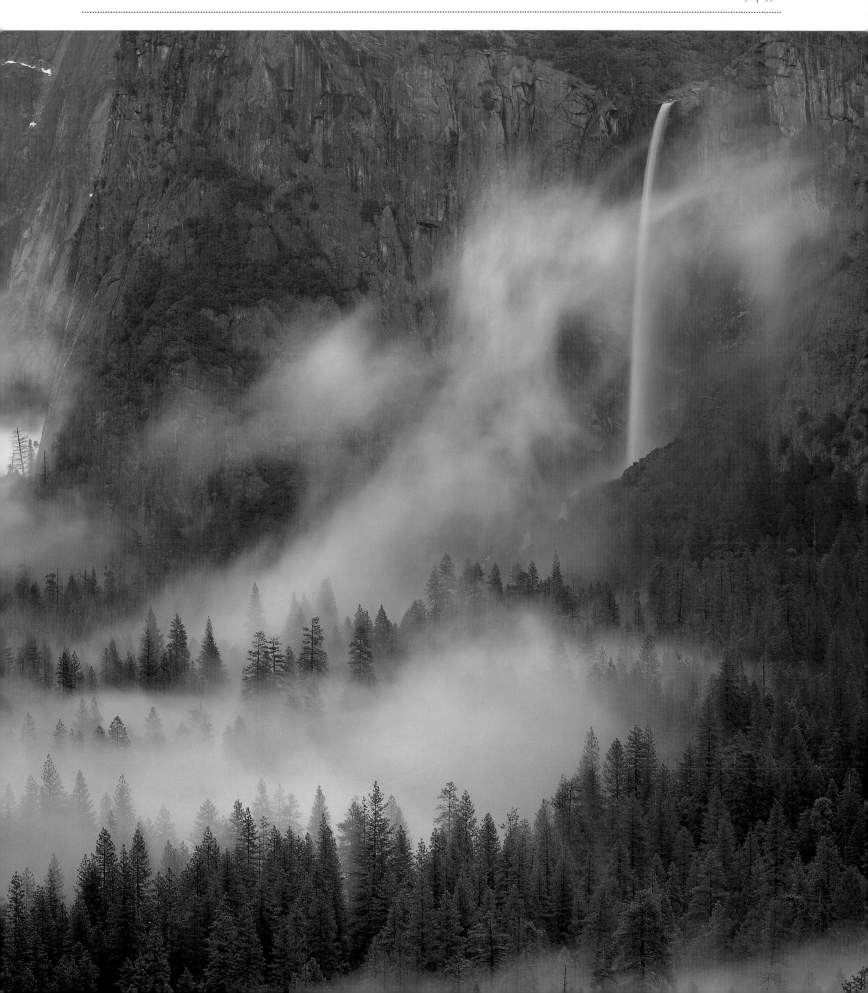

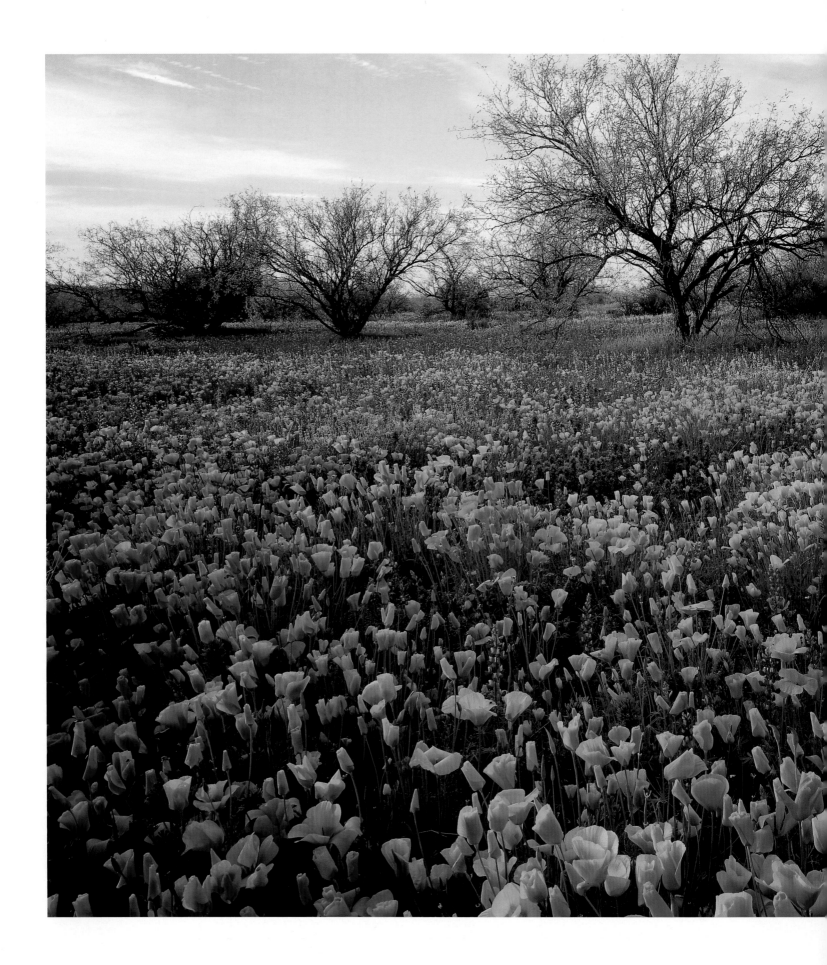

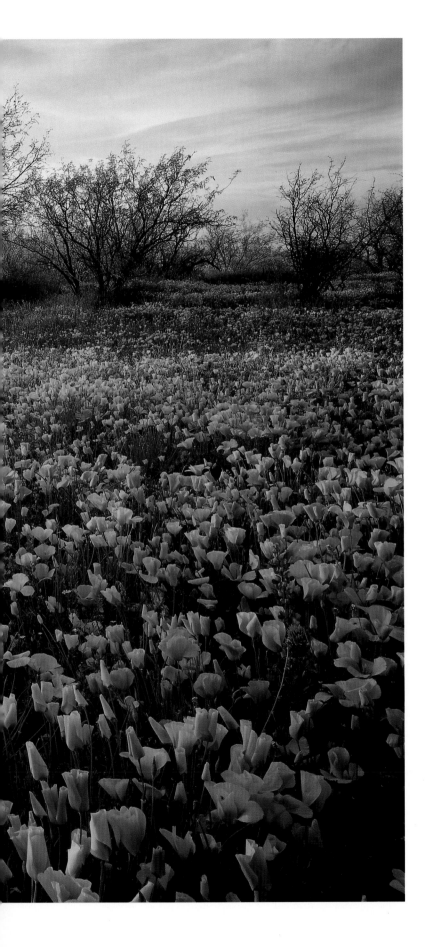

Career

Field of poppies *(Eschscholtzia californica)*, lupine *(Lupinus sparsiflorus)*, and red owl's clover *(Orthocarpus purpurascens)* in evening light. Quinlan Mountains, Tohono O'odham Reservation, Arizona

N ow that you've come back from the field, processed the film, and carefully edited the shoot, what's next? I spend as much time editing and captioning images as I do creating them in the field. You must have detailed captions and you must know where your images are at all times, if you want to market your images professionally.

Keeping Track The advent of the personal computer, and its ability to read bar codes, makes keeping track of images quite simple. My system, Agave SPS, was developed for photographers by photographer Randy Prentice. With it, I'm able to track images and all their dupes, assign various client rights to each image, and search by client, key word, format, or contact person. I can print submission forms with ASMP (American Society of Media Photographers) contract language, as well as with every number of every image. I can also choose to print the entire caption along with that number, or even print a thumbnail (small) image on the submission form. This program is so good that a small army of the top pros now swear by it.

If you feel your work is worthy of publication, you must care enough to caption it correctly, track it carefully, and protect it with contracts that reflect the highest industry standards. You must also display your images in mounts that allow editors to view your photographs easily with all information prominently displayed. I worked as a picture editor for about seven years, both in Chicago and Tucson; ask any editor, and they'll tell you: Lack of clear caption information is a major reason images are rejected.

Once, a client lost 55 of my prime original images. It's absolutely the worst thing that can happen! Were it not for the professional nature of my captioning, submission forms, and complete tracking of each image, my claim would have been rather weak. I not only had each image tracked by submissions to the client, but I also had a paper trail from FedEx. I received a fair settlement (though not as much as I wanted).

Clients notice how you package and ship your work. It's a further reflection on the value of the images. So, if you're telling a client that your work is worth the $1500 per image standard, then pack it and ship it in a manner reflecting that value.

OPPOSITE: *Die-cut 4 x 5 transparency mounts, submission forms, and submission terms provide both caption information and contact information. The bar codes make tracking images an easy proposition.*

A Note About Shipping

I live in the desert where temperatures can easily hit 110 degrees Fahrenheit. At times, our office receives returned images shipped via many carriers (especially those using dark-colored trucks) other than FedEx, and the packages arrive so hot that we have to place them in a cool room and open them immediately! The white vans that FedEx uses really do make a difference—especially for film.

Ideas My interest in environmental issues drives my work. Out of that concern, I've joined and supported environmental groups, learned of critical habitats and threatened public lands, and along the way, made friends with many naturalists doing research projects.

You don't need to flit about this country's national parks searching for the perfect Delicate Arch photo. There are photographic opportunities everywhere, often right in your backyard. Find an issue, a landscape in peril. Make it your personal project. Read all you can. Become an expert. Document the place in all seasons with your photography.

When you've assembled a good selection of images, seek help from a professional photographer you respect. Together, brainstorm and edit for potential markets. Many of my book projects began as magazine stories. Seek out writers who share your interest and together draft query letters to publications.

Perhaps publication isn't for you. You may want to create images to exhibit as fine-art prints. I believe we are in a very exciting time for printmaking. With recent advances in digital technology, we can scan 4 x 5 transparencies at a very high resolution, color correct them in Photoshop, and output them to Lightjet machines producing Fuji Crystal Archive prints with amazing quality. With this process we can burn, dodge, and color correct like never before.

I recently was asked to print a collection of images for a Phoenix Art Museum show as part of an *Arizona Highways* retrospective of the work of Ansel Adams, David Muench, and myself. With company like that, of course I was terrified! I wanted the very best prints. I tried several types of prints, including traditional cibachromes. I had already decided to print on cibachrome

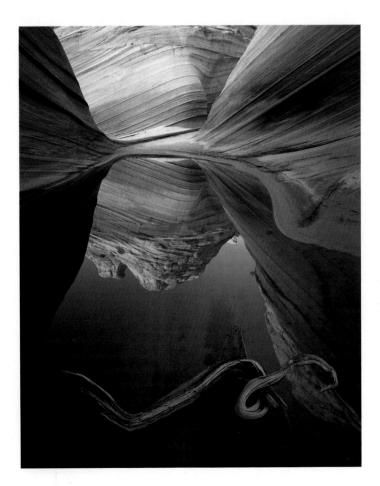

Here, again, is the image on page 70 before being scanned for fine-art digital print output.

OPPOSITE: *After color management in Photoshop, subtle highlights were brought out. The foreground root was "held back," recreating that cleaner, sunbleached look that I remembered when I took the photograph. Much of the cyan-colored light in the shadow areas was removed.*

material but decided to call fine-art printmaster and former Apple Computer innovator Bill Atkinson. He attempted to bring me "up to speed"; together we scanned images on his Heidleburg Tango drum scanner and burned the results onto several CD-ROMS. Due to the pressing show deadlines, I enlisted the help of Rich Seiling of West Coast Imaging in Oakhurst, California, to supervise additional Photoshop adjustments for the final prints.

The resulting prints left me speechless. Many of the critical reviews wondered aloud how such incredible prints were made. I urge anyone interested in digital printmaking to visit the Ansel Adams Gallery in Yosemite and see the work by Charles Cramer or William Niell. It was their work that first caught my eye. I'm sure that you too will be impressed.

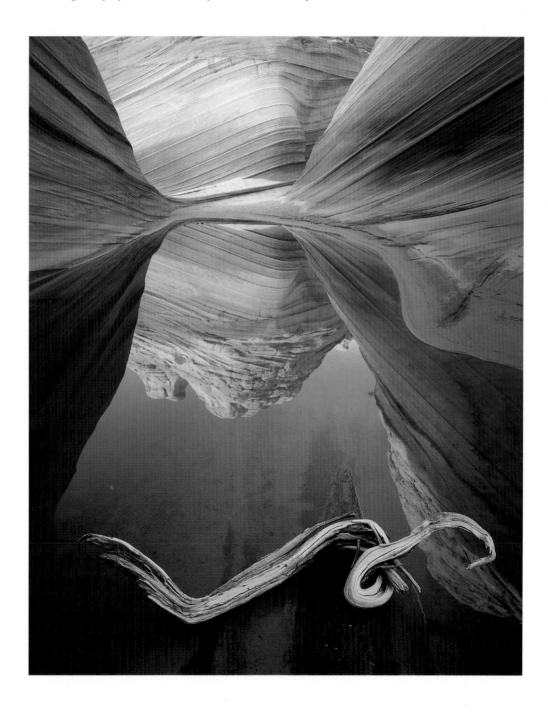

Personal Vision What we photograph, how we frame it, and our choice of lens defines our unique vision. It's how we see. We see a composition, plan for optimum light, and record that vision on film. Today, however, many photographers see a successful image published by another photographer and set about recreating that image. Sure, we all learn from those who've gone before. It's a continuum. However, copying images made by others merely to turn a profit is not only devoid of personal vision, but also theft. It's a hollow representation that forever taints the offending photographer.

Been-there-done-that trophies are what many photographers seek. They seem to think that by copying those visual icons by Ansel Adams, Philip Hyde, David Muench, and others somehow their work is validated. It's not. These photographers are merely copy machines with legs.

They're missing the very best thing about being a photographer: the simple act of searching for images and that sense of discovery. It gets the creative juices going. My preconceived notions rarely pan out. I usually find something better along the way, often right at my feet. If I knew ahead of time the images I would return with at the end of each trip, I'd quit in a heartbeat!

You just never know when that spiritual combination of light, good fortune, and timing will come together and speak to you. I do, however, know that when I'm working the hardest, I'm also the luckiest. When I love the landscape and listen to it, I'm spiritually inspired. My heart sings.

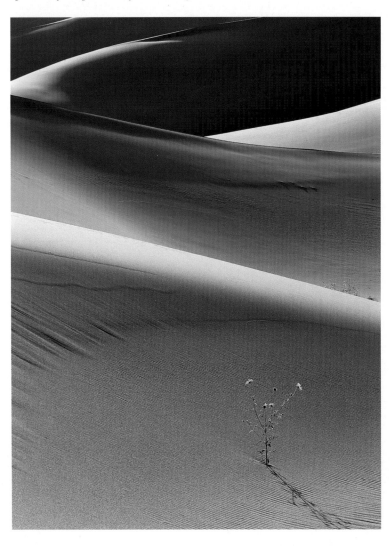

Prairie sunflowers *(Helianthus petiolaris)* flowering on the dunes. Great Sand Dunes National Monument, Colorado

Arca-Swiss F-Field camera with Schneider APO-Tele-Xenar HM 400mm lens

Hiking out on the dunes, I had the preconceived notion of photographing windblown dune patterns. I was surprised by blooming sunflowers in the "bowls" between the dunes.

OPPOSITE: Heartleaf arnica *(Arnica cordifolia)* carpeting the coniferous forest, charred from the 1988 fire.

Arca-Swiss F-Field camera with Schneider Super-Angulon 75mm lens

While passing through Yellowstone after the great fire of 1988 ravaged its forests, I was in a bleak state of mind, seeing death everywhere. However, when I parked my truck to go for a hike, I was stunned to see carpets of yellow, blooming arnica amid the scorched trees. My bleakness was replaced by a feeling of hope.

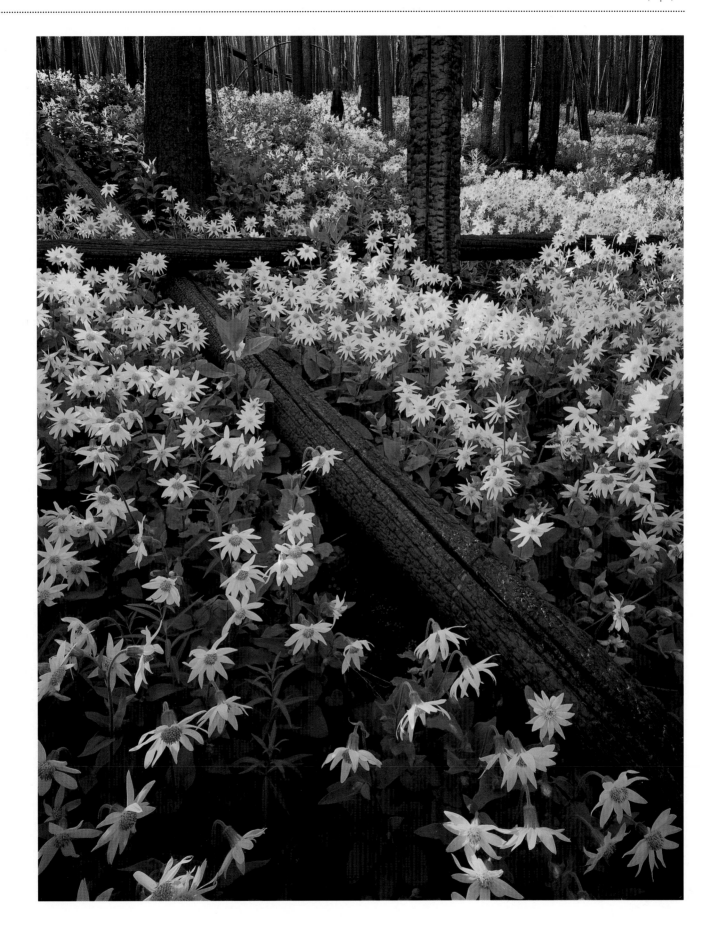

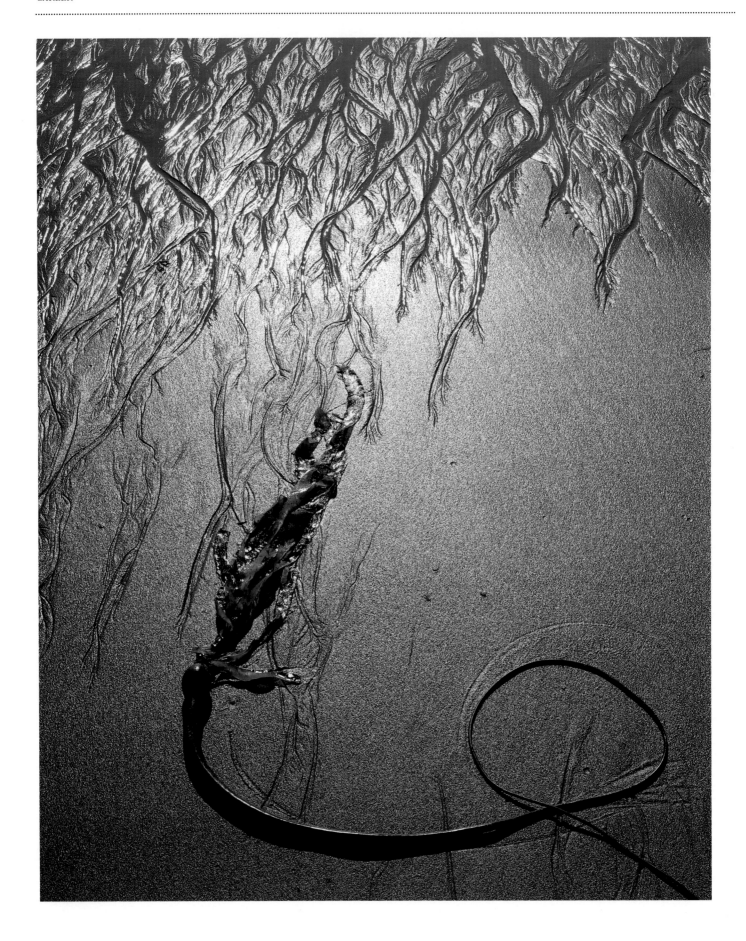

Resources

**Agave SPS, Rosette Software
Randy Prentice**
P.O. Box 13308
Tucson, AZ 85732
ph: (520) 749-3788 or
(520) 743-8493
www.prenticephoto.com/agaveweb.htm
*Labeling, stock photography business management
software.*

**American Society of Media
Photographers (ASMP)**
150 North Second Street
Philadelphia, PA 19106
ph: (215) 415-2767
www.asmp.org
*Professional photographers' association leading the way
in establishing industry business practices.*

Arca-Swiss
ph: (773) 248-2513
www.arca-swiss.com
Manufacturer of cameras and tripod heads.

Calumet Photographic
ph: (800) 225-8638
www.calumetphoto.com
*Photographic equipment. Retail stores in California,
Illinois, Massachusetts, and New York, as well
as in the United Kingdom, the Netherlands, Germany,
and Belgium.*

fotoQuote
ph: (800) 679-0202
www.fotoquote.com
Stock photography sales pricing software.

Four Wheel Campers
ph: (800) 242-1442
www.fourwheelcampers.com
*"Pop-top" lightweight, sturdy campers that make a
great base camp for wilderness photographers.*

Fuji Photo Film
ph: (800) 755-3854
www.fujifilm.com
Photographic films.

**Gitzo Tripods
Distributor: Bogen Photo Corp.**
565 East Crescent Avenue
Ramsey, NJ 07446
ph: (201) 818-9500
www.gitzo.com
Manufacturer of tripods and tripod heads.

Justin Gnass
336 Broadway, Suite #24
Chico, CA 95928
ph: (530) 893-9362 or (888) 277-1187
jgnass@shocking.com
*Lens and film pouches specifically made for large-
format photography.*

Kirk Enterprises
333 Hoosier Drive
Angola, IN 46703-9336
ph: (800) 626-5074
Customer support ph: (219) 665-3670
www.kirkphoto.com
Maker of specialty camera support devices.

Kodak
ph: (800) 242-2424
www.kodak.com
Photographic films.

Lowepro
P.O. Box 6189
Santa Rosa, CA 95406
ph: (707) 575-4363
www.lowepro.com
Photographic cases, bags, and backpacks.

One World Journeys
www.oneworldjourneys.com
*Worldwide photographic expeditions documenting
endangered wildlife and habitats.*

Pentax
35 Inverness Drive East
Englewood, CO 80112
ph: (800) 877-0155
www.pentaxusa.com
Manufacturer of cameras and spot light meters.

Photo Craft Labs
3550 Arapahoe Avenue
Boulder, CO 80303
Professional liaison: John Botkin
ph: (800) 441-3873
www.pcraft.com
Custom processing lab.

Schneider Optics
285 Oser Avenue
Hauppauge, NY 11788
ph: (631) 761-5000
www.schneideroptics.com
*Maker of large-format lenses and B+W
optical-glass filters.*

Tempe Camera Repair
606 W. University Drive
Tempe, AZ 85281
ph: (480) 966-6954
www.tempecamera.com
*Photographic supplier and camera modification and
repair facility.*

The Tiffen Company
90 Oser Avenue
Hauppauge, NY 11788-3886
ph: (631) 273-2500 or (800) 645-2522
(for the name of a Tiffen dealer)
www.tiffen.com
Maker of photographic filters.

West Coast Imaging
49774 Road 426, Suite B
Oakhurst, CA 93644
ph: (800) 799-4576
www.westcoastimaging.com
Digital lab.

OPPOSITE: Sea kelp and tidal patterns.
Shi Shi Beach, Olympic National
Park, Washington

**Arca-Swiss F-Field camera
with Schneider APO-Symmar
180mm lens**

*Personal vision allows us to see compositions—
often right at our feet. Here, backlighting helped
me to emphasize the simplicity of a strand
of sea kelp amid the sand patterns caused by
the receding tide.*